Images of Modern America

JOHN F. KENNEDY
FROM FLORIDA TO THE MOON

Front Cover: President Kennedy inspects the cockpit of *Friendship 7*, John Glenn's space capsule, at Cape Canaveral the day after Glenn's successful orbit of Earth. The president had presented Glenn with the NASA Distinguished Service Medal in an earlier ceremony. More than 100,000 people were on hand as the president honored Glenn for his "courage and outstanding contribution to human knowledge." (JFK Library, Knudsen.)

Upper Back: In September 1962, President Kennedy made a two-day, four-stop swing through NASA facilities in Florida, Alabama, Missouri, and Texas. He spoke before 50,000 people at Rice University in Texas, articulating why "we choose to go to the moon." He asked, "Why climb the highest mountain? Why, 35 years ago, fly the Atlantic? Why does Rice plays Texas?" He answered, "We choose to go to the moon . . . and do the other things, not because they are easy, but because they are hard." (JFK Library, Knudsen.)

Lower Back Cover (from left to right): President Kennedy presents Alan Shepard the NASA Distinguished Service Medal at the White House. The ceremony occurred on May 8, 1961, just three days following Shepard's successful suborbital flight. Seventeen days later, the president set America's goal to reach the moon by 1970. (JFK Library, Knudsen.); Neil Armstrong and "Buzz" Aldrin pose next to the US flag on the moon, July 21, 1969. Armstrong, Aldrin, and Apollo Lunar Module pilot Mike Collins fulfilled President Kennedy's goal set on May 25, 1961, with 162 days left in the decade. (NASA.); President Kennedy and Wernher von Braun look skyward as von Braun gives the president a briefing on the Saturn rocket at Cape Canaveral. It was November 16, 1963, and von Braun was scheduled to have dinner at the White House on Monday, November 25, when the president returned from Texas. (JFK Library, Stoughton.)

Images of Modern America

JOHN F. KENNEDY
FROM FLORIDA TO THE MOON

Raymond P. Sinibaldi

Copyright © 2019 by Raymond P. Sinibaldi
ISBN 978-1-4671-0306-0

Published by Arcadia Publishing
Charleston, South Carolina

Printed in the United States of America

Library of Congress Control Number: 2018967903

For all general information, please contact Arcadia Publishing:
Telephone 843-853-2070
Fax 843-853-0044
E-mail sales@arcadiapublishing.com
For customer service and orders:
Toll-Free 1-888-313-2665

Visit us on the Internet at www.arcadiapublishing.com

To Jake, Addy, Brady, Reagan, Quinn and Owen, Drew, Sean, Rylie, and Jack. My future stars: "Ask not what your country can do for you—ask what you can do for your country."

Contents

Acknowledgments		6
Introduction		7
1.	Cape Canaveral: The Early Years	9
2.	Choosing the Moon: JFK Sets America's Sight	23
3.	Into Orbit: John Glenn Leads the Way	47
4.	The President's Coming: JFK Wants to Know	69
5.	The Original Seven: JFK and the Mercury Astronauts	81
6.	Mission Accomplished: We Made It, Mr. President	93

Acknowledgments

To Karen, Kate, Ann Marie, John, Toni, and the entire staff of the Hanson Public Library in Hanson, Massachusetts, where much of this was written—the warmth of your energy feels like home, and for that, I am most grateful. To Maryrose, Stacey, Abby, Michael, and James of the JFK Library, thank you for your professionalism, help, and ever-pleasant demeanor; I never tire of being there. To my girl, Charley, for your wonderful company and our week in Petaluma, you are a true pal. Angela and Josh, thanks for sharing the summer of a lifetime, which brought a deeper understanding of the joys of Earth and my place in it. Lynda, you brought down the stars and, with them, purpose; I hope you find yours. Caitrin and Ryan, I love working with you guys. Thanks go to Lisa and Paul DeWispelaere for your passion and photograph and Mark Semanko for sharing his drawing and memories. And lastly, to Pres. John F. Kennedy, Alan Shepard, Virgil "Gus" Grissom, John Glenn, Scott Carpenter, Gordon Cooper, Walter M. "Wally" Schirra, and Donald Kent "Deke" Slayton, thank you for your vision, your courage, your love of country, and for your service. America and the world are better because of you. All White House photographs were taken by either Robert Knudsen, Cecil Stoughton, or Abbie Rowe. They appear courtesy of the JFK Library and are designated by simply their last names. AC denotes the author's own collection, and RPS are photographs taken by the author. The words attributed to JFK come from his speeches, available at the JFK Library, and quotes of the astronauts come from either *Light This Candle: The Life and Times of Alan Shepard* by Neal Thompson, *John Glenn: A Memoir* by John Glenn with Nick Taylor, *Liberty Bell 7: The Suborbital Mercury Flight of Virgil I. Grissom* by Colin Burgess, or *We Seven: By the Astronauts Themselves* by Carpenter, Cooper, Glenn, Grissom, Schirra, Shepard, and Slayton.

INTRODUCTION

It was October 4, 1957, and the Milwaukee Braves and New York Yankees arrived in Milwaukee to resume the World Series. The Braves had defeated New York the day before, evening the series at one game apiece. When they awoke the following morning, the world had changed forever. "Reds Launch First Artificial Satellite, Moon Speeds Around Earth at 18,000 Miles per Hour," screamed the headlines of the *Wisconsin State Journal*, which knocked the World Series and the Braves off the front page.

"Mankind Enters the Space Age, Soviet Moon Circles Earth," declared the *Lincoln Star* to the citizens of the heartland of Nebraska. "Russ Reach Outer Space First" was the word in California, while the *Pittsburgh Press* put it simply, "Russia Wins Space Race." On the East Coast, the breaking news bulletin headline of the *New York Daily News* shouted, "Earth Moon Launched-Reds." A little farther north, the *Boston Globe*, in a manifestation of the era, had a morning headline yelling, "Russia Launches Satellite, Moon Circles Earth Every 95 Minutes"; while its day's final edition was updated to "You Can't See It . . . Tracked By Radio." In the West Texas town of El Paso, Texans were informed, "Soviets Have Moon As Missiles Goal, Declare Space Travel Only a Few Years Off."

In Fort Lauderdale, Florida, 180 miles south of Cape Canaveral, the *Fort Lauderdale Daily News* dedicated 75 percent of its front page to coverage of this remarkable Soviet achievement. "It's Just a Baby Moon, But It Shines Brightly" was caste atop the front page, and just below, it grasped the essence of its worldwide significance "Casts Beams of Prestige Upon Russians For Being First."

"Russia has won a race to step first into space with a baby moon," wrote Associated Press science reporter Alton Blakeslee. Capturing the romantic aspects of space travel he continued, "Something fashioned by human hands and minds is whirling around the world as a Columbus of space. That's the tremendous initial impact. A link is broken in the chain binding humans to earth. Baby moons are the first messengers . . . to answer some mysteries of the void between earth, sun and stars."

The sense of wonder, so aptly expressed by Blakeslee, was accompanied with a deep sense of foreboding as well. "Top ranking personnel" of the US satellite project at Cape Canaveral offered comments but asked not to be named. Recognizing the "tremendous scientific achievement," their concern was paramount. "Frankly it's enough to scare the hell out of me," said one. "If they can do that, they can drop ICBM's [Intercontinental Ballistic Missiles] on us." The Soviet Union's launch of *Sputnik* in October 1957 sent a cold chill down the collective spine of the United States.

In 1957, Sen. John F. Kennedy was a member of the Senate's McClellan Committee, which was investigating racketeering within US labor unions. One of its targets was teamster president Jimmy Hoffa. Hoffa had been before the committee during the summer of 1957 and pleaded the Fifth Amendment. Despite that, he was reelected teamster president and shared the front pages with the launch of *Sputnik*.

Wernher von Braun was the technical director and chief of the Guided Missile Development Division in Huntsville, Alabama, when *Sputnik* was launched into space. The exceptional rocket scientists and Kennedy had met once before. It was shortly after Kennedy's election to the Senate in 1952 and pre-*Sputnik*. Both were in New York as part of a panel to nominate *Time* magazine's Man of the Year. The two conversed for about an hour before dinner, and von Braun recollected the following in his oral interview for the JFK Library: "The discussion touched on quite a number of subjects . . . the Senator spent at least half the time on his older brother Joseph who was killed during the war in an airplane accident that was closely related to the fledging missile technology." With Senator Kennedy doing most of the talking on a wide range of topics, von Braun found himself "greatly impressed by the breadth of his interests and the broad spectrum of his knowledge." "In fact," the rocket scientist intoned, "I told my wife I wouldn't be surprised if Senator Kennedy would one day be President of the United States."

A decade earlier, nine days and a half a world apart, both narrowly escaped death in World War II.

As the thick summer clouds had swallowed the stars and obliterated the Pacific moon, a palpable darkness hung over Blackett Strait in the South Solomon Islands. It was August 1, 1943, and Lt. John F. Kennedy was on the bridge of *PT-109*, one of three PT boats forming a picket along the strait, hoping to find and inflict damage upon the Tokyo Express. At 2:30 a.m., out of the darkness, emerged *Amagiri*, a Japanese destroyer. Initially mistaken for another PT boat, the *Amagiri* was instantaneously upon them, splitting *PT-109* asunder and hurling the crew into the sea. Thus, began an ordeal that would see the 11 survivors, led by Kennedy, swim for miles in the Pacific Ocean, hopping islands seeking rescue and refuge from the enemy. The weeklong ordeal came to an end when friendly natives carried a message from Kennedy, carved into a coconut, to an Australian outpost on the island of Rendova. All were rescued not knowing the historical significance their saga at sea would come to hold. The story of the *PT-109* would catapult the 26-year-old Kennedy to a political career, which landed him in the White House 17 years later.

Nine days after the rescue of Kennedy and his crew, 31-year-old rocket scientist Wernher von Braun, head of Germany's rocket team, was taking refuge at Peenemünde on Germany's Baltic Sea. Nearly 600 British and American bomber planes blitzed the German Army research center as part of Operation Crossbow. It was at Peenemünde where the Germans developed the V-2 rocket, thus making it a prime target for the Allied-led assault upon Germany's long-range weapons program.

Born only 11 years after H.G. Wells wrote *The First Men on the Moon*, von Braun was captivated as a youth by the writings of both Wells and Jules Verne. It was, however, Hermann Oberth's 1923 classic study, *By Rocket to Space*, that lit a fire in von Braun that burned for the rest of his life.

The German rocket scientist and the American lieutenant paradoxically would join forces nearly 20 years later—the lieutenant, now president of the United States, with a vision, and the scientist, now an American citizen, providing the means to bring that vision to fruition. Together, they embarked on mankind's greatest adventure. And this, after both of their young lives were nearly lost within days of each other while fighting on opposite sides of the world during its most devastating war.

Within days after the launch of *Sputnik*, von Braun was before the Pentagon telling them that a US satellite launch was two to four months away, and Sen. John F. Kennedy, his eyes already on the 1960 presidential race, was speaking in St. Johns in New Brunswick, Canada. Downplaying the success of the Russian launch, he told the crowd that the United States remained ahead of the Soviets in missile technology.

Syndicated columnists Drew Pearson ended his column on the subject as follows: "The United States has lost so much scientific face recently that government scientists are now determined to beat the Russians on at least one thing—Reaching the moon." The German-born rocket scientist's and the Massachusetts's junior senator's destinies awaited them both. And a little stretch of land off the coast of Florida would become center stage as the launching pad to the moon.

One

Cape Canaveral
The Early Years

The first human inhabitants of what is now known as Cape Canaveral trace back at least 12,000 years. Its name, however, reaches back about a half of millennium, to the Spanish conquistador Juan Ponce de León. In 1513, while in his pursuit of the ever elusive fountain of youth, he stumbled upon this little strip of land he called Cabo ("end" or "tip") Canaveral ("an area of sugarcanes"). By the end of the century, the cape was marked on the maps of European explorers and had become somewhat of a landing zone for shipwrecked sailors.

The shores off Cape Canaveral would witness the last naval battle of the American Revolution in 1783 and a series of lighthouses (1838–1894) to warn mariners of the broken ground and shoals extending some 13 nautical miles off its coast. A devastating hurricane in 1885 chased the homesteaders and discouraged further settlements as a 10-foot storm surge crashed over the barrier island. The beach near the Cape Canaveral Lighthouse was so severely eroded that Pres. Grover Cleveland asked Congress for funding to move the landmark, which was accomplished in 1894.

Undaunted by hurricanes or the threat thereof, Charles P. Horton, an 1890 graduate of Harvard University, founded the Harvard Club, which also came to be known as the Canaveral Club. Originally 12 members, the membership was capped at 20 with its intent to vacation, hunt, and fish. A three-story, 22-room lodge was constructed on a knoll off Canaveral's Chester Shoals near what was to become Kennedy Space Center's Launchpad 39B.

On May 11, 1949, Pres. Harry Truman signed legislation that established the Joint Long Range Proving Ground at Cape Canaveral with its primary purpose to test missiles. In August 1950, it was named Patrick Air Force Base in honor of Gen. Mason Patrick, who, in 1926, became the very first chief of the Army Air Corps. Throughout the early part of the decade, the ongoing testing of missiles moved forward with an eye toward placing a satellite in Earth's orbit in 1957–1958 to celebrate the International Geophysical Year, a yearlong series of global activities that would allow scientists to observe various geophysical phenomena.

On October 4, 1957, everything changed.

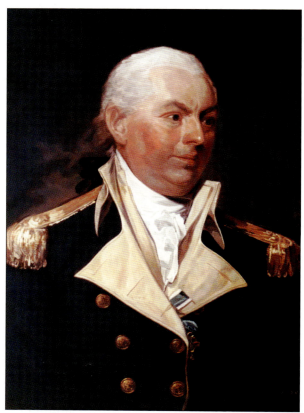

A mystical thread connects JFK to Cape Canaveral, and it runs through the American Revolution and Capt. John Barry, an Irish Catholic immigrant from County Wexford, Ireland. On December 7, 1775, which is 166 years to the day World War II began, Barry received the first command of a US warship under the continental flag. He commanded four ships, including the *Alliance*, which won the American Revolution's final naval battle off Cape Canaveral's coast. On May 29, 1781, which is 136 years to the day of JFK's birth, Barry was seriously wounded on the *Alliance*. He died September 12, 1803, and is buried in the graveyard in Philadelphia's St. Mary's Catholic Church. JFK, whose paternal grandparents hailed from County Wexford, Ireland, served in the US Navy and was married on September 12, 1953, in St. Mary's Catholic Church in Newport, Rhode Island. In 1963, he paid tribute to Barry while visiting Ireland. (Left, Gilbert Stuart; below, Knudsen.)

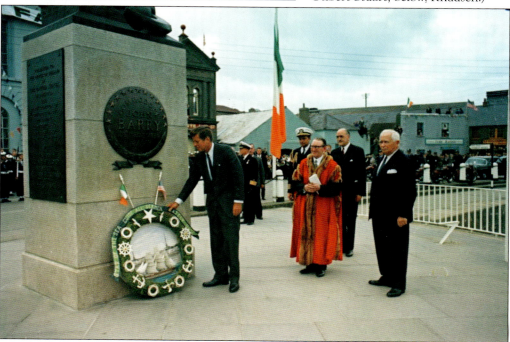

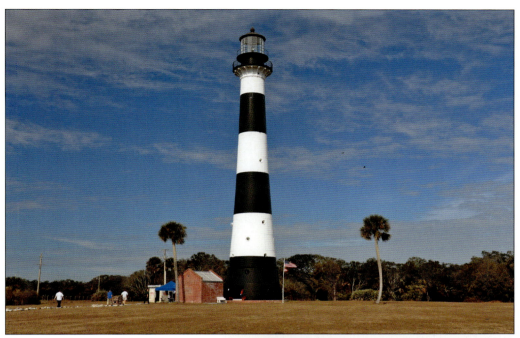

The Cape Canaveral Lighthouse has had three incarnations. First built in 1848, it was rebuilt in 1868 on the same site. Following threats of erosion, it was disassembled and moved by mules a mile inland where it was relit on July 25, 1894. It was last restored in 2007. (AC.)

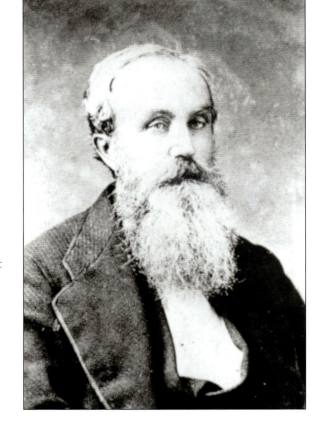

Born in Vermont in 1817, Mills Olcott Burnham was raised in Troy, New York, before moving to Florida in 1837. He was the first sheriff of St. Lucia County in 1847 and served in the Florida House of Representatives from 1847 to 1851. He was the lighthouse keeper from 1853 until 1883. He is buried in the Burnham family plot on Cape Canaveral. (North Brevard Historical Society.)

The lodge housed the members of what was known as the Harvard Club, the Boston Club, and the Canaveral Club. Built on 18,000 acres of land purchased for $1 an acre in 1890, it was in disrepair by the 1920. The lodge never recovered and was burned for fire practice by the Air Force in the 1950s. This is yet another serendipitous link to JFK, who was a 1940 Harvard graduate. (North Brevard Historical Society.)

Pres. Harry Truman inspects the Honor Guard as he departs the Orlando Air Force Base on March 8, 1949. Two months later, he signed a bill creating the Joint Long Range Proving Ground at Cape Canaveral. (Harry S. Truman Library.)

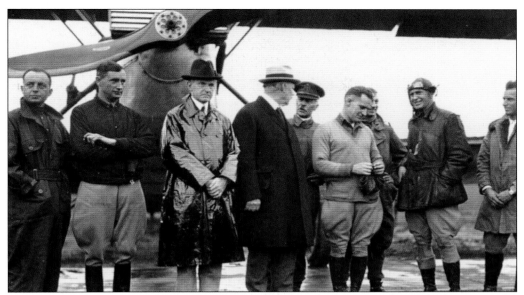

On August 1, 1950, the Joint Long Range Proving Ground was renamed Patrick Air Force Base after Gen. Mason Patrick, the first chief of the Army Air Corps. In this photograph, President Coolidge meets the fliers at Bolling Field in Washington, DC, around 1925. From left to right are Lieutenants Arnold and Smith, President Coolidge, Secretary of War John W. Weeks, General Patrick, Lieutenant Wade, Gen. Billy Mitchell, and Lieutenants Nelson and Ogden. (NASA.)

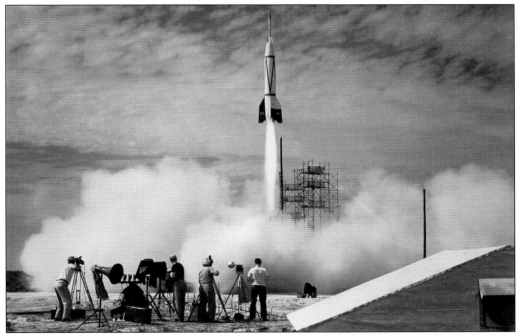

One week earlier, on July 24, 1950, Cape Canaveral saw the launch of its first rocket. Named the *Bumper 8*, it was a two-stage rocket program that topped a V-2 missile base. The upper stage was able to reach then-record altitudes of almost 250 miles, higher than the space shuttles flew. *Bumper 8* was used primarily for testing rocket systems and for research on the upper atmosphere. (NASA.)

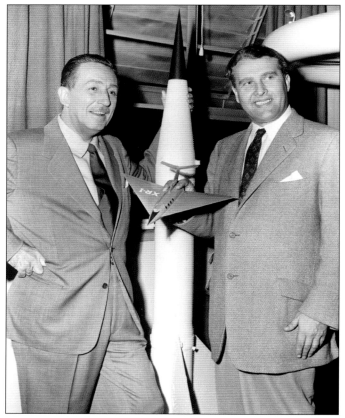

Wernher von Braun (right), seen with Walt Disney around 1954, and John F. Kennedy, seen below in his Senate office around 1955, met shortly after JFK's election to the Senate in 1952. They were both in New York as part of a panel to nominate *Time*'s Man of the Year. Von Braun was impressed by Kennedy's curiosity and knowledge on a plethora of topics. He recollected the following in his oral interview for the JFK Library: "I found it extremely fascinating to listen to him. Whenever he was through with one subject, I would raise a question on something entirely different and invariably I found him most responsive and concise." (Left, JFK Library; below, NASA.)

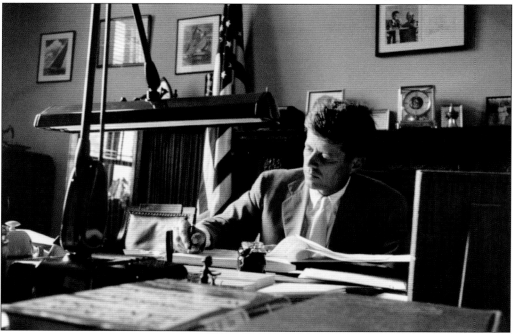

On the evening of October 4, 1957, Dr. Wernher von Braun was at a dinner at the Redstone Arsenal in Huntsville, Alabama. The occasion was the honoring of President Eisenhower's new secretary of defense delegate, Neil McElroy. A phone call took von Braun away from the table, and *Time* magazine of February 17, 1958, reports that, upon his return to the table, he spoke to McElroy about the launch of *Sputnik*. Von Braun stated, "Sir, when you get back to Washington you'll find that all hell has broken loose . . . keep one thought in mind . . . we can fire a satellite into orbit 60 days from the moment you give us the green light." The launch of the Russian's *Sputnik* captivated the world and forced the United States to spring to action. The postcard at right was sent to Americans who were members of the Communist Party. (Both, AC.)

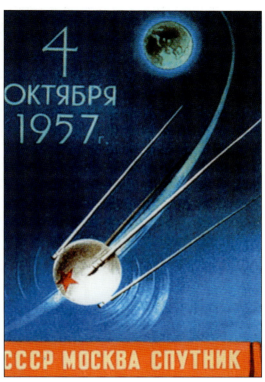

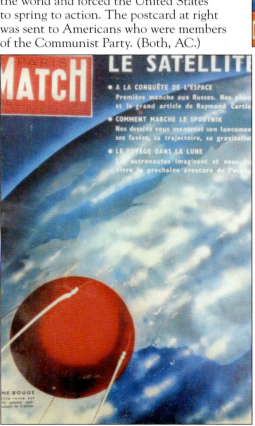

Despite the fact that President Eisenhower downplayed the launch and CIA chief Allan Dulles said that he was "not surprised," behind closed doors was another matter. A White House evaluation report, written October 16, 1957, stated, "The Soviet system has gained scientific and technological superiority . . . credibility has been sharply enhanced . . . and will have a clear advantage in the Cold War." There was fear that *Sputnik* would mean a "validation of the Soviet System . . . Particularly if . . . unmatched . . . by the West." (Dwight Eisenhower Library.)

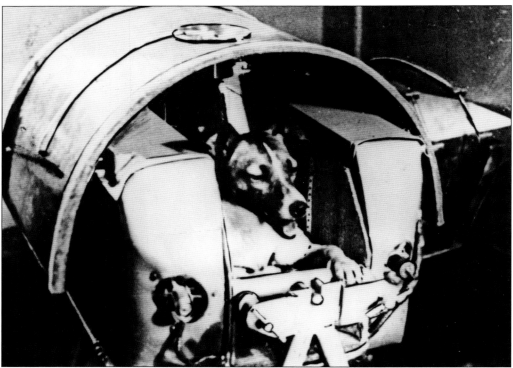

Thirty days later, on November 3, the Soviets launched their second satellite *Sputnik II*. Only this time, a mammal, a dog named Laika, was aboard and sacrificed for the cause. The Soviets were castigated in some circles for their cruelty to the animal. With America's first satellite still sitting on a launchpad, the trepidation about falling behind the Soviets was only intensified. (Russian News Agency TASS.)

On December 6, *Vanguard*, America's answer to *Sputnik*, exploded on Cape Canaveral's launchpad. A malfunction caused the vehicle to lose thrust and explode. The attempt to match the Soviet's successes was a dismal failure that increased America's trepidation even more. Newspapers across the country used words such as "Flopnik" and "Kaputnik" to describe the failure. (US Navy.)

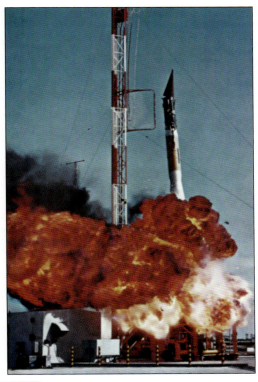

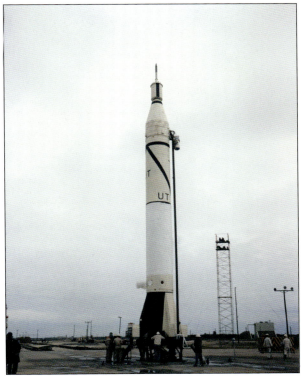

On January 31, 1958, the United States joined the Soviets in space with the successful launch of *Explorer I*. Its primary objective was to measure the radiation environment in Earth's orbit. In an experiment designed by Dr. James Van Allen of the University of Iowa, *Explorer I* found the radiation belt that now bears Van Allen's name. In fact, there are two of them. (NASA.)

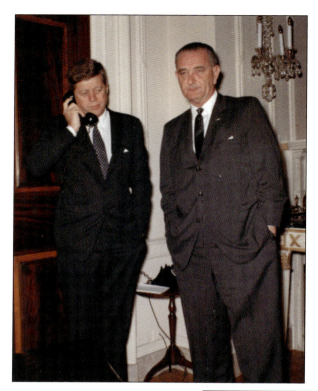

On November 25, Senate Majority Leader Lyndon Johnson, seen here with JFK in 1962, began hearings on American space and missile activities in the Preparedness Investigating Subcommittee of the Senate Armed Services Committee. This began the process that led to the creation of NASA, which came into being on July 29, 1958, when President Eisenhower signed the National Aeronautics and Space Act into law. (Stoughton.)

T. (Thomas) Keith Glennan was NASA's first administrator. The National Aeronautics and Space Act clearly articulated eight objectives. Among the objectives were "the expansion of human knowledge of phenomena in the atmosphere and space," "the preservation of the role of the United States as a leader in aeronautical and space science and technology," and "cooperation by the United States with other nations . . . in work done pursuant to this Act and in the peaceful application of the results thereof." (NASA.)

On October 11, 1958, *Pioneer I* became the first space vehicle launched by NASA. Launched from Cape Canaveral as a moon probe, it never made it. It did, however, reach heights of 71,000 miles and did gather some useful scientific data regarding radiation in the atmosphere and Earth's magnetic field. (NASA.)

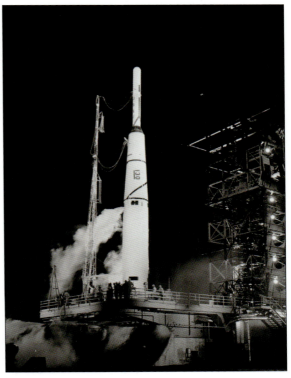

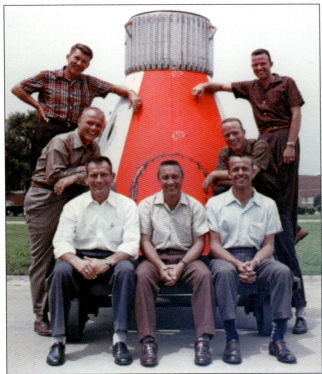

On April 9, 1959, NASA selected the men who would pilot America into the Space Age, the Mercury Seven. Starting on the top left and working around are Wally Schirra, John Glenn, Deke Slayton, Gus Grissom, Alan Shepard, Scott Carpenter, and Gordon Cooper. Three were Air Force pilots (Cooper, Grissom, and Slayton); three were Navy pilots (Carpenter, Schirra, and Shepard); and Glenn was a Marine pilot. (Walter Schirra Collection, San Diego Air and Space Museum.)

The space race would play a role in the presidential election of 1960. Richard Nixon (below) was Eisenhower's vice president for eight years. Eisenhower's seeming indifference to the fact that the Soviets' space successes increased their world standing at the expense of the United States hurt Nixon. Kennedy hit Nixon and the Eisenhower administration hard and often. One such jab was during a speech he gave in Kansas City just two weeks before the 1960 election: "Our failure to be first in outer space . . . cost us heavily in prestige." He defined prestige as "influence . . . our ability to persuade people to accept (our) point of view . . . It persuaded people in underdeveloped countries that the Soviet Union . . . was now the equal and the superior to some degree of the United States." This message resonated and surely played a role in Kennedy's narrow victory. (Above, JFK Library; below, Nixon Library.)

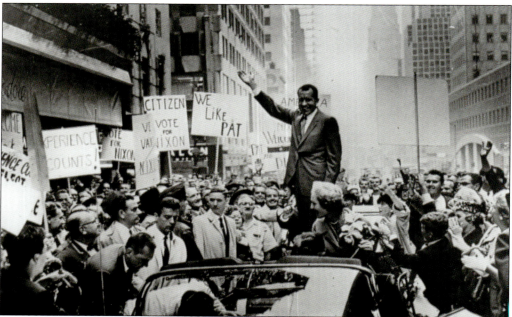

On November 8, 1960, John F. Kennedy defeated Richard Nixon in what remains one of the closest elections in American history. Kennedy garnered 34,220,984 votes accounting for 49.72 percent of the vote while Nixon chalked up 34,108,157 votes for 49.55 percent. Despite the narrow margin of the popular vote victory, Kennedy's 303 electoral votes put him in the White House. At 3:18 p.m. on the same day, NASA launched *Little Joe 5*. An unmanned atmospheric test flight of the Mercury spacecraft was also to test the launch escape system. Sixteen seconds after liftoff, both rockets fired prematurely, and two minutes and six seconds later, they were destroyed on impact with the Atlantic Ocean. (Right, AC; below, NASA.)

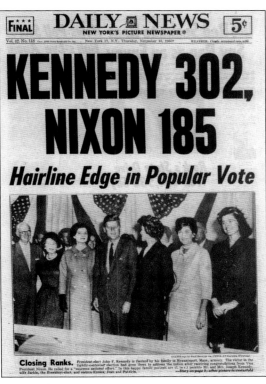

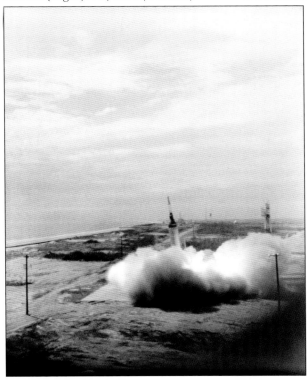

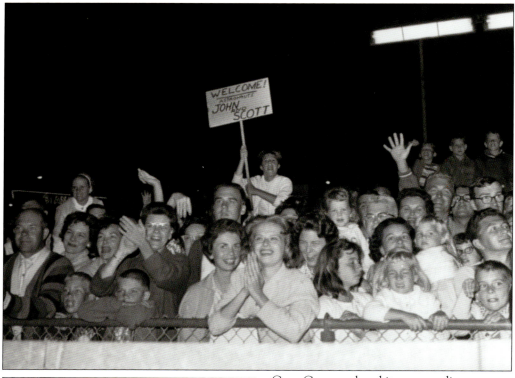

Cape Canaveral and its surrounding area was about to be transformed and would give birth to what came to be known as Florida's Space Coast. Locals welcomed, cheered, and adored the astronauts who would now be in their midst. In the photograph above, the sign welcomes two in particular, John Glenn and Scott Carpenter. The area would take on the look of a "space town." For example, this pay phone (left) from Cocoa Beach bears the shape of a Mercury space capsule. (Above, Mark Irwin Collection, San Diego Air and Space Museum; left, AC.)

Two

Choosing the Moon
JFK Sets America's Sight

During the 1960 campaign for president, the United States launched 37 rockets toward space. Cape Canaveral, Florida, deployed 16; Edwards Air Force Base, California, 12; and Wallops Island, Virginia, 1. A total of 43 percent of the launches (13) were categorized as failures. Meanwhile, the Soviet Union launched eight rockets toward the heavens with five of them failing. However, the successful launch and return of *Korabl-Sputnik 2* recorded another first for the Soviets as this flight was the first to place animals in orbit and return them safely. Canines Belka and Strelka were the primary passengers; however, they were accompanied by a gray rabbit, 42 mice, 2 rats, and a few flies. All passengers survived the flight, but Belka had seizures during the fourth orbit. This led to the Soviet decision to limit the first man in space to only three orbits. Less than one month after the inauguration of President Kennedy, the Soviets successfully launched *Venera I*, a satellite probe marked for Venus.

It was clear the Soviets still held the advantage in the space race, although the United States was hot in pursuit, averaging a launch (or an attempt at one) about every 10 days. The major difference, besides in number, was the fact that all the United States' efforts were open for scrutiny while the Soviets' failures were not known until decades later.

It was in this environment that John F. Kennedy was sworn in as the 35th president of the United States on January 20, 1961. The Cold War was as hot as it had ever been, and the United States was vulnerable because of the Soviet Union's advancements in rocket technology. The United States' sense of urgency was increased when Russia's Yuri Gagarin became the first man in space in April.

The seven Mercury astronauts embodied the idea that Kennedy had vigorously articulated in his inaugural address: "The torch has been passed to a new generation of Americans." And the exploration of space embodied the ideals of his "New Frontier."

On May 5, the United States answered when Alan Shepard became America's first man in space, and three days later, President Kennedy met with all the astronauts at the White House as America crowned its new hero. A mere 20 days after Shepard's suborbital flight of 15 minutes and 22 seconds, John F. Kennedy set America's sights on the moon. Decades later, NASA flight director Gene Kranz recalled listening to the president, "I couldn't believe it." He was not alone as many within NASA thought he was "crazy." However, as Kranz let it seep in, he thought, "Holy cow, what a challenge, what a job, this guy trusts us when we haven't been able to put a guy in orbit."

It had taken nearly three years for NASA to put a man in space for 16 minutes. They now had a little less than nine years to get to the moon. America went to work.

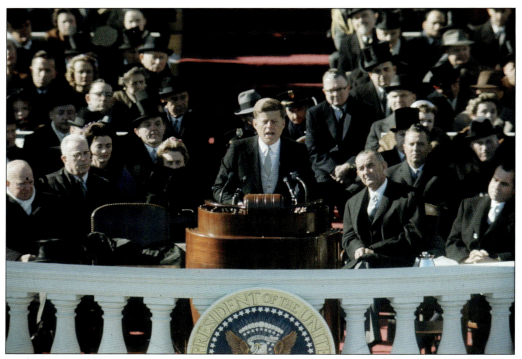

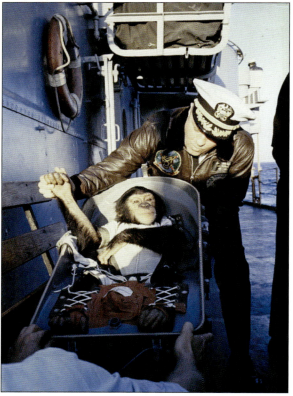

By the time of John F. Kennedy's January 20, 1961, inauguration (above), 13 different primates, 2 dogs, and about 30 mice had given their service to US space exploration. Eight of the primates and all but two mice had given their lives. On January 31, Ham the Chimp (left) was launched from Cape Canaveral and successfully completed a 17-minute suborbital flight. He is welcomed home by Comdr. Ralph Brackett of the USS *Donner*. This was supposed to be the final flight before the first launch with a human pilot; however, difficulties with the booster engine turbopump caused the escape rocket to take Ham to an altitude of 157 miles instead of the planned 115 miles and caused him to overshoot the landing mark by 130 miles. This delayed the manned flight for one more Redstone rocket test on March 24. (Above, JFK Library; left, NASA.)

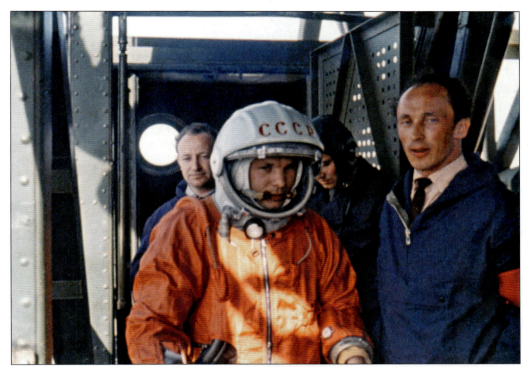

On April 12, 1961, Russian cosmonaut Yuri Gagarin became the first human in space when he orbited Earth three times. He parachuted by the Volga River and came upon a peasant girl who asked him if he came from outer space. "I am Soviet" was his reply, and "I've come from outer space." President Kennedy sent the following telegram to Soviet premier Nikita Khrushev: "The people of the United States share with the people of the Soviet Union their satisfaction for the safe flight of the astronaut in man's first venture into space. We congratulate you and the Soviet scientists and engineers who made this flight possible. It is my sincere desire that in the continuing quest for knowledge of outer space our nations can work together to obtain the greatest benefit to mankind." (Above, Russian News Agency TASS; right, JFK Library.)

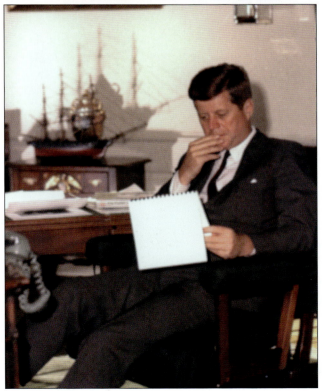

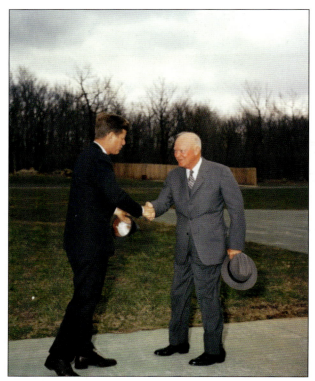

Five days after the Soviet Union made space history again with the Gagarin flight, the United States suffered another public relations debacle with the failed Bay of Pigs invasion of Cuba. Sponsored and planned by the CIA, with planning and training begun under the Eisenhower administration, some 1,500 Cuban Nationals hit the beach at the Bay of Pigs on April 17. The CIA convinced both Presidents Eisenhower and Kennedy that the Cuban people would raise up and join the counter-revolution and take down Fidel Castro. That was not to be the case, and ultimately, close to 1,200 prisoners were taken. Eisenhower met with Kennedy at Camp David on April 22, and the two strolled the grounds alone. The photograph below, captured by White House photographer Robert Knudsen, depicts the isolation of leadership. (Both, Knudsen.)

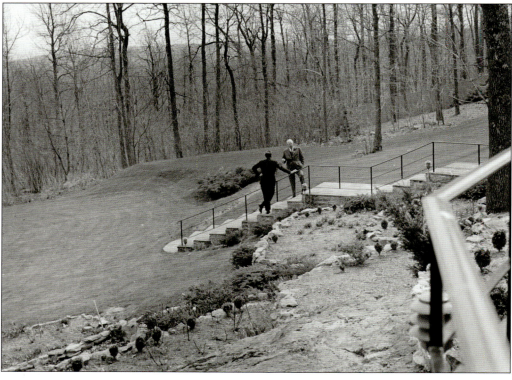

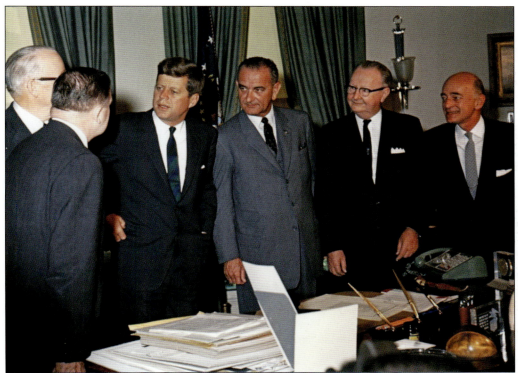

On April 25, 1961, President Kennedy signed HR 6169 in the Oval Office. The bill made Vice Pres. Lyndon Johnson director of the National Space Council. From left to right are NASA chief James Webb; Sen. Robert Kerr, JFK, LBJ, Rep. Overton Brooks, and National Space Council executive secretary Edward Welsh. As Senate majority leader, Johnson was instrumental in crafting the legislation that created NASA in 1958. (Knudsen.)

On April 26, Gus Grissom was performing egress training upon the waters off Cape Canaveral. This training would prove paramount in saving Grissom's life three months later when the hatch of his capsule, *Liberty Bell 7*, malfunctioned. Grissom named his vehicle after the Liberty Bell due its shape and even had a crack painted on its side to honor the symbol of American freedom. (NASA.)

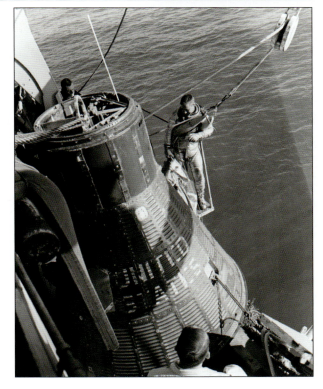

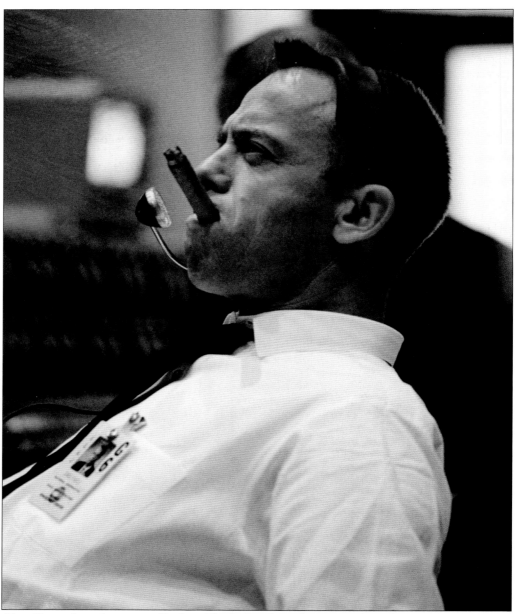

Alan Shepard was four years old when Charles Lindberg flew across the Atlantic Ocean. Lindberg was his boyhood hero and sparked an interest in flying that would drive Shepard his entire life. For Christmas 1937, his mother gave him his first airplane flight. He boarded a DC-3 at the Manchester, New Hampshire, airport. He flew the half hour flight to Boston, boarded another DC-3, and returned. With his life course now set, he worked at tending chickens financed by his grandmother. Selling eggs for 29¢ a dozen, he saved his money and purchased a new bike, which he would pedal the 12 miles to the airport from his Derry, New Hampshire, home to watch the planes take off and land. He would serve as a fighter pilot in Korea, and despite his clashes with authority and brash flying maneuvers, he would rise through the ranks and ultimately become America's first man in space and the only Mercury astronaut to walk on the moon. (NASA.)

At 9:34 a.m. on May 5, 1961, Comdr. Alan Bartlett Shepard Jr. became the first American in space when his *Freedom 7* spacecraft successfully completed a 15-minute, 28-second suborbital flight. NASA's Gene Kranz said Shepard's flight was "literally fraught with danger and it was the one we had to make happen if we were going to keep moving in space." Shepard, pictured right, entered the capsule, which was positioned atop the Mercury Redstone rocket, pictured below, and found "an enticing piece of pinup art on the control panel" and a sign which read 'No Hand Ball Playing in this Area.'" Both were courtesy of fellow astronaut John Glenn. Glenn and Shepard were competitive rivals to become the first American in space. Their relationship, which began somewhat acrimonious, grew into a great friendship. (Both, NASA.)

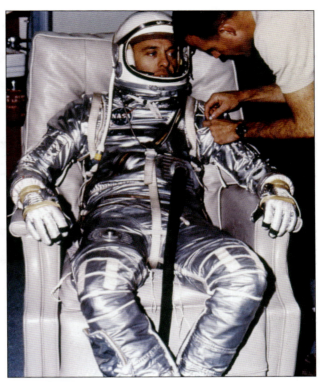

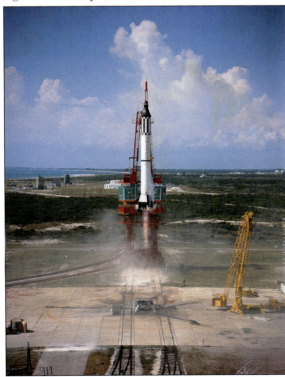

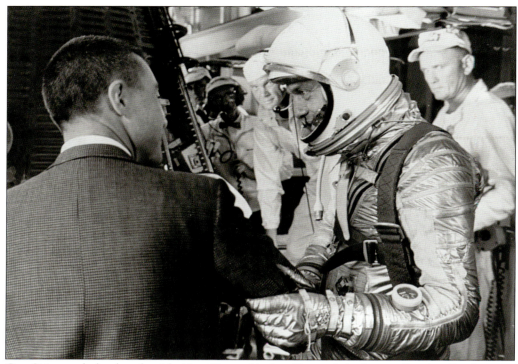

Gus Grissom shakes hands with Alan Shepard before Shepard climbs into *Freedom 7* to become America's first spaceman. To the right of Shepard, John Glenn can be seen looking on. Shepard was chosen to be first, Grissom would follow him three months later, and John Glenn would become the first American to orbit Earth in February 1962. Glenn was the backup pilot for both Shepard and Grissom. In the photograph below, Shepard awaits his launch seated in the capsule. Over two hours of delays presented Shepard with an unanticipated problem as provisions for bathroom breaks were not considered. The repeated delays found Shepard saying to Gordon Cooper on the ground, "Man I've got to pee." Cooper checked into that possibility and delivered the following message from Wernher von Braun: "Zee astronaut shall stay in zee nose cone." He did, and he peed. (Both, NASA.)

Pres. John F. Kennedy and others (above) watch television coverage of Shepard's liftoff in presidential secretary Evelyn Lincoln's office. From left to right are Comdr. Tazewell Shepard (naval aide to the president), Lyndon B. Johnson, Robert F. Kennedy, Richard Goodwin, Paul Nitze, Arthur Schlesinger Jr., David E. Bell (in doorway) and JFK. Evelyn Lincoln wrote in her diary that JFK was "afraid of the reaction of the public in case there was a mishap." The president's pensiveness is visible on his face. In the photograph at right, the president and First Lady Jacqueline Kennedy look on intently while awaiting word on a successful splashdown. During a 2.5-hour delay of the flight, an impatient Shepard snapped to Mission Control, "Why don't you just fix your little problem and light this candle?" *Light This Candle* became the title of Shepard's autobiography published in 2004. (Both, Stoughton.)

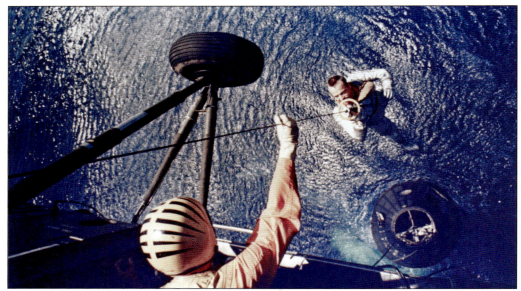

Shepard is pulled from the waters of the North Atlantic Ocean by a marine helicopter from the USS *Lake Champlain*. As pilot Wayne Koons made his way to the deck of the ship, Shepard observed a moving blanket of white. As they drew closer, Shepard realized the blanket was the sailors of the ship wildly cheering him. It was at that moment that Alan Shepard realized the magnitude of what he had just accomplished, and it brought a tear to his eye. Years later, he recalled that moment as "the most emotional carrier landing that I ever made." Exhilarated after the success of the flight, an hour later, Shepard received a phone call from President Kennedy. "And then the President came on . . . I was even more thrilled at that moment talking to him, than I had been after the flight." (Both, NASA.)

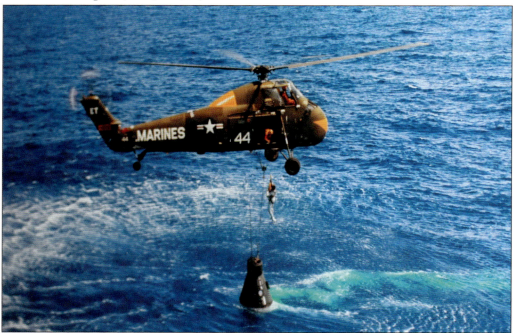

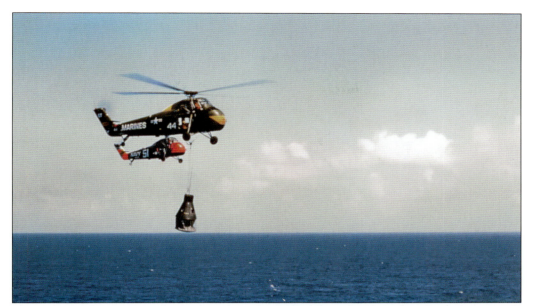

Shepard's *Freedom 7* received a similar ride to the deck of the *Lake Champlain*. From August 1959 until Shepard's launch, there were 17 unmanned flights, three of them carrying monkeys: Sam, Miss Sam, and Ham. A significant number of failures occurred, including the destruction of the launch vehicle by the range safety officer just 10 days earlier. Today, it is on display at the JFK Library and Museum. (NASA.)

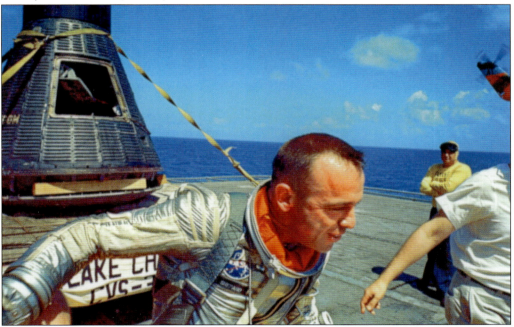

Shepard disembarks from the chopper and makes his way across the deck of the *Lake Champlain*. Waving to the cheering sailors, he yelled to them, "What a ride." Waiting to welcome him aboard with a handshake was the ship's captain, Ralph Weymouth. Taking his hand, America's first man in space said, "Hi, I'm Al Shepard." (NASA.)

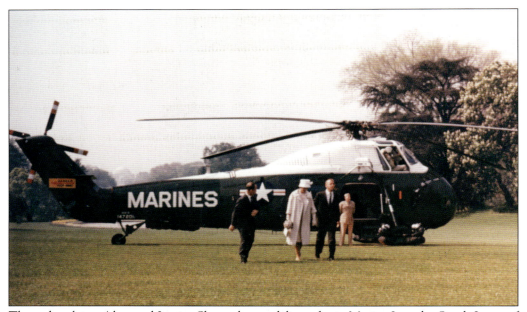

Three days later, Alan and Louise Shepard were delivered, via *Marine I*, to the South Lawn of the White House where Commander Shepard was presented the NASA Distinguished Service Medal. Here, the couple makes their way across the lawn accompanied by NASA's public affairs officer, Lt. Col. John A. Powers. (Knudsen.)

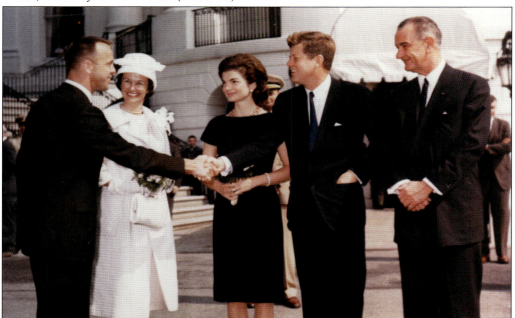

The Shepards are greeted by President and First Lady Kennedy as well as Vice Pres. Lyndon Johnson. Just days earlier, JFK signed a bill making Johnson the chairman of National Space Council. In his remarks to those gathered, Shepard said, "I thought last Friday was a thrilling day . . . Today even surpasses last Friday . . . I got far less sleep last night than I did before the flight." (Knudsen.)

President Kennedy pins the NASA Distinguished Service Medal on Alan Shepard. JFK sprinkled his remarks with humor. After introducing several NASA administrators, he mentioned that nobody really knew these names and then said, "If this flight had not been such an overwhelming success, these names would be known to everyone." (Knudsen.)

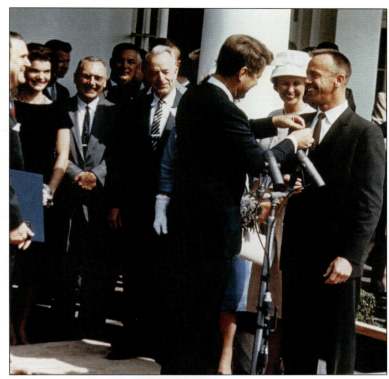

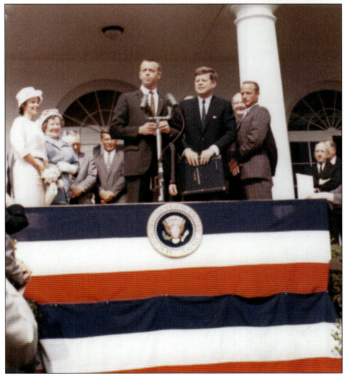

Addressing the gathering, which included his fellow Mercury astronauts, Shepard deflected the attention bestowed upon him. Stating that he was "mindful at this moment of the honor being bestowed upon me . . . It really should go to the hundreds of people who made my flight possible . . . It is really to these hundreds of people that the accolades should go." (Knudsen.)

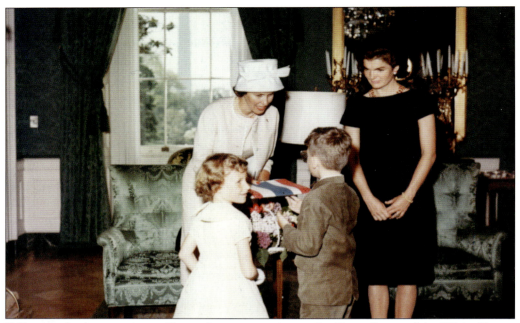

Following the presentation to Shepard was a reception in the Green Room of the White House. Jacqueline Kennedy and Louise Shepard chat with two unidentified children as they hand one a package. (Knudsen.)

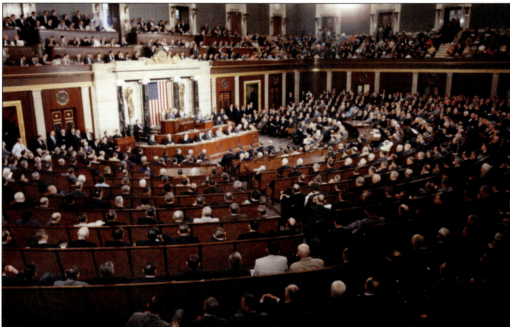

On May 25, President Kennedy delivered a Special Address to Congress on urgent national needs. Acknowledging the Soviet lead in space, he set the goal for the moon. "I believe that this nation should commit itself to achieving the goal, before this decade is out, of landing a man on the moon and returning him safely to the earth." America was struck with "moon fever." (Stoughton.)

The day after Kennedy's address, *Freedom 7* went on display at the Paris International Air Show. In nine days, some 650,000 people viewed the spacecraft. Within weeks after Shepard's flight, the civic leaders and members of Congress, in letters to President Kennedy, urged that *Freedom 7* should be retired to St. Louis. Citing its rich aviation history and the fact that it was built in St. Louis, it seemed a perfect fit. In a June 19 letter to Congressman Frank Karsten, Kennedy expressed that NASA had received "dozens of requests from cities throughout the United States . . . It would be more appropriate to have it placed on permanent display in one of our national museums." Given to the Smithsonian Institution, it was on display at the Naval Academy from 1998 through 2016 before being moved to the JFK Library and Museum in Boston (both photographs) where it awaits a permanent home in Washington, DC. (Right, JFK Library; below, RPS.)

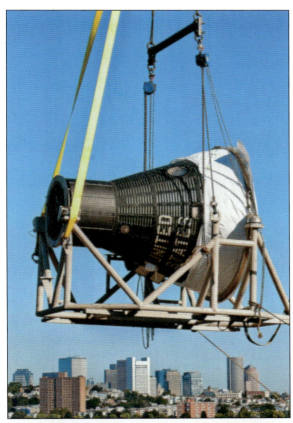

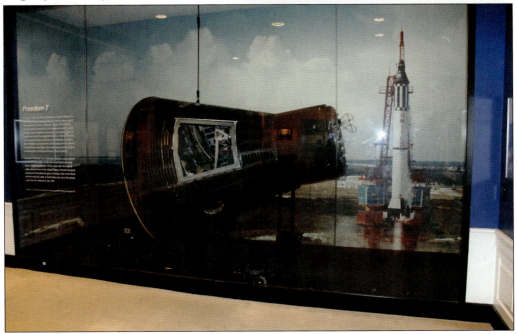

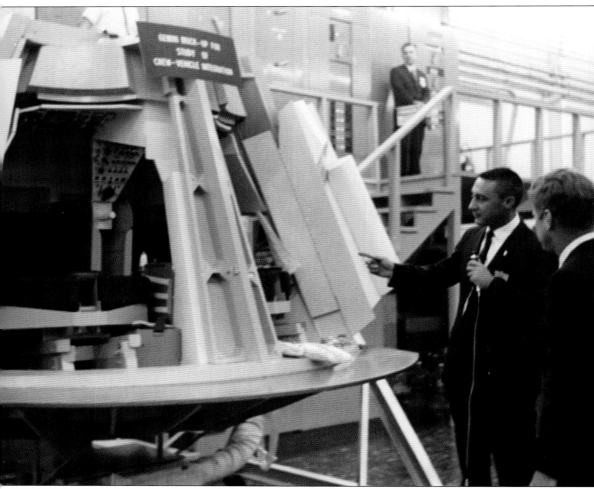

Gus Grissom was born in Mitchell, Indiana, on April 3, 1926, the oldest of four children. Described by his youngest brother, Lowell, as an underachiever in high school, he did maintain high grades in math and science. This would ultimately lead him to Purdue University where he graduated in 1950 with a degree in mechanical engineering. An Air Force fighter pilot in Korea, he flew 100 combat missions in six months, earning both the Air Medal with Oak Leaf Cluster and the Distinguished Flying Cross. Ultimately, the test pilot would be chosen one of America's original Mercury astronauts, and early on, he, along with Alan Shepard and John Glenn, would be named one of the first three Americans in space. Here, Grissom, holding a microphone, explains to President Kennedy the inner workings of the two-man Gemini capsule in September 1962. (Knudsen.)

Deke Slayton, who would be in charge of choosing the flight crew through the late Mercury and Gemini flights, said that "once Kennedy pointed us at the moon, Cocoa Beach FL became Spaceport USA. We thought we died and went to heaven." Fellow astronaut Frank Borman found it to be a "wild place, [with a] wide open, raucous, frontier type of existence." Scott Carpenter called it "a boomtown with lots of pretty girls, lots of heroic men and abandon." A NASA secretary characterized it saying, "There were women on the beach wanting attention from an astronaut . . . then another . . . then another. It was unbelievable and no one ever said a word." It did not take long for the space industry to take hold, which is on display in the photograph below. The nation's eyes and attention were on space and Cape Canaveral and Cocoa Beach, Florida. (Both, AC.)

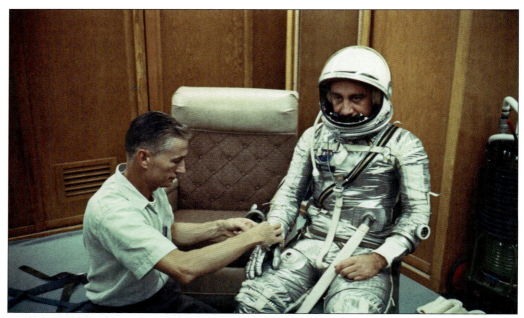

Chosen for the second suborbital flight, Gus Grissom and his *Liberty Bell 7* were scheduled for launch on July 16, 1961. Weather caused postponement of that flight as well as the rescheduled one of July 18. In both cases, Grissom got fully suited, ready to go, but never climbed into the spacecraft. (NASA.)

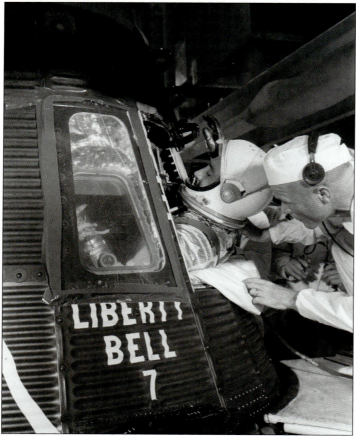

A third attempt, scheduled for July 19, was scrubbed after Grissom spent four hours waiting. He got to within 10 minutes of liftoff. Finally two days later, backup pilot John Glenn assisted him into *Liberty Bell 7* for the fourth time. Grissom became the second American to lay his eyes upon space. (NASA.)

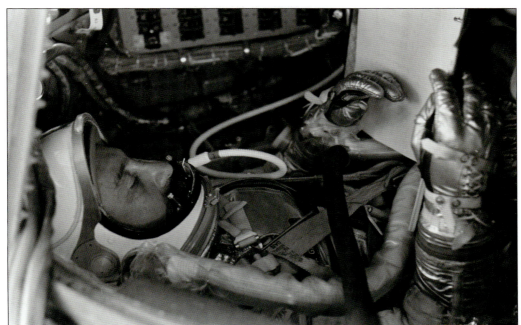

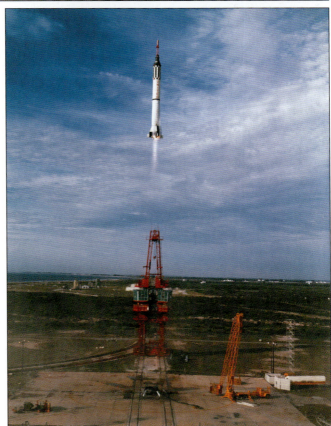

Gus Grissom was awoken at 1:05 a.m. on July 21, thus beginning his fourth attempt to launch *Liberty Bell 7*. After a brief physical and mental exam, he was pronounced ready to go. A few minutes after 3:00 a.m., his pressured suit checked and cleared, and he made his way to the transfer van, arriving at the launchpad at 3:51 a.m. Carrying his portable air-conditioner, he walked to the elevator. Taking the 65-foot ride up and having a final check of the capsule and suit, Grissom settled into the couch of *Liberty Bell 7*. At 7:20 a.m., following 41 minutes of delay, Grissom (above) heard fellow astronaut Deke Slayton call ignition and then felt the vibrations of the starting engines. Finally on his way, Grissom observed, "The sky became a darker blue until approximately two minutes after liftoff . . . the sky rapidly changed to an absolute black." (Both, NASA.)

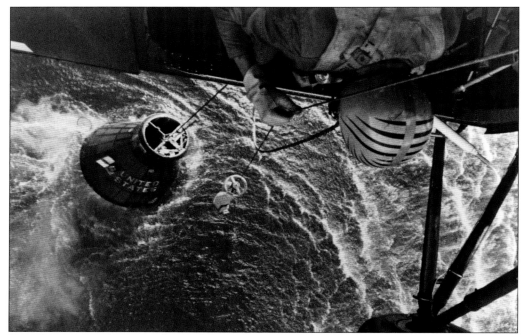

Just 15 minutes and 37 seconds after liftoff and falling at 28 feet per second, *Liberty Bell 7* plunged into the Atlantic Ocean, just off Cape Canaveral. Landing with a mild jolt, in a few moments, the window was underwater, and Grissom thought he might be upside down. The capsule righted itself; however, Grissom heard what he described as a "disconcerting gurgling noise." While waiting instructions, Grissom heard a thud, and without any warning, the hatch to his capsule was gone, blown out into the ocean. Looking up he saw the beautiful blue summer sky and the rather alarming sight of the Atlantic Ocean spilling into his capsule. "I made two moves," said Grissom, "I tossed my helmet . . . and hoisted myself right out through the hatch." Copilot Lt. John Reinhard lowers a horse collar to Grissom, but this attempt to raise him had to be aborted. The dot to the right of the capsule in the photograph below is Grissom. (Both, NASA.)

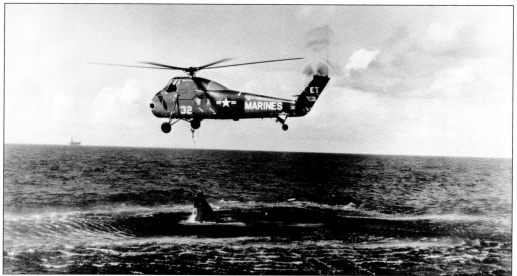

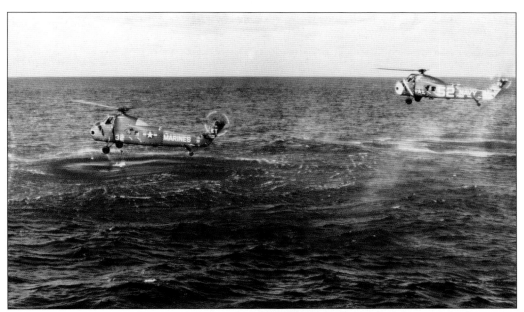

The drama of Liberty Bell 7 is unveiled in these two photographs. In the photograph above, just below Marine Chopper No. 32, Grissom attaches the hook to the cable atop Liberty Bell 7 to pull it out of the water. The pilot made several attempts to raise the vessel, which now weighed well over 1,000 pounds more than normal due to the water inside. Unbeknownst to either pilot was that Grissom's space suit was also taking on water, and he is now perilously close to sinking himself. "I was floating lower and lower in the water," Grissom said. "I had to swim hard just to keep my head up and I thought to myself . . . You've gone through this whole flight and now you're going to sink right here in front of all these people." Suffering from engine difficulties, Chopper No. 32 had to move off, and Chopper No. 30 moved in to recover Grissom. (Both, NASA.)

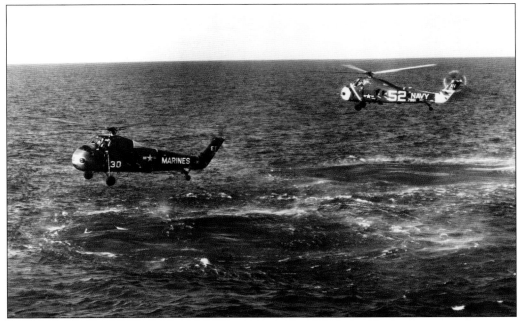

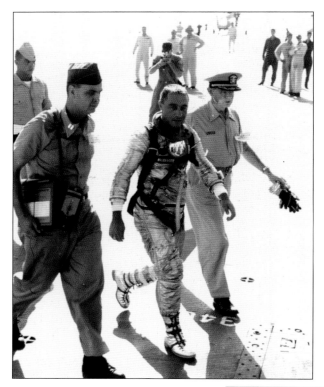

An exhausted Gus Grissom crosses the deck of the USS *Randolph* flanked by medical officers, Army captain Jerome Strong (left) and Navy commander Robert Laning. At Mercury Control Center, the report came in from Chopper No. 30: "We are attempting to recover the astronaut." NASA chief Chris Kraft related, "The minute dragged on forever, then we heard it, Gus was aboard the chopper." (NASA.)

Safely aboard the *USS Randolph*, Grissom received a call from the White House, and JFK told him, "I've been watching on TV here and I am delighted that you got through alright . . . It was a wonderful job and we're all delighted it worked out well for you." In typical Grissom humility he responded, "I hope this does something for you like Commander Shepard's does." (NASA.)

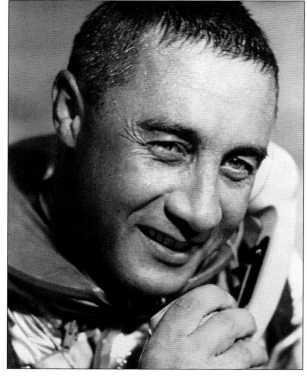

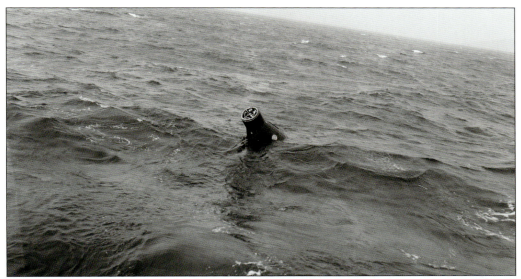

With 45 minutes until the scheduled launch, a pad technician discovered that one of the 70 hatch bolts was misaligned. During a 30-minute hold that was called, McDonnell and NASA Space Task Group engineers decided that the 69 remaining bolts should be sufficient to hold the hatch in place and blow it at the appropriate time. The misaligned bolt was not replaced. The hatch blew early, Grissom was rescued, and Liberty Bell 7 sank. (NASA.)

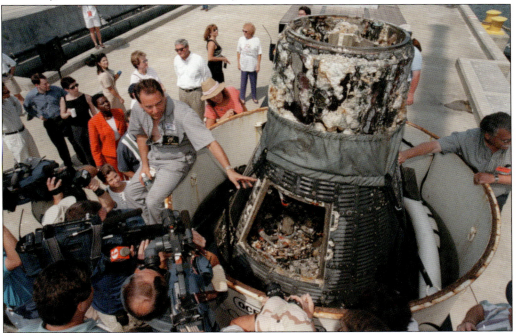

Liberty Bell 7 settled at a depth of 15,000 feet. It was raised in an expedition funded by the Discovery Channel on July 20, 1999; one day short of the 38th anniversary of Grissom's launch and exactly 30 years to the day of Apollo 11's moon landing, Liberty Bell 7 saw land again. It toured Germany in 2014 and was on display at the Children's Museum in Indianapolis in Grissom's home state. (NASA.)

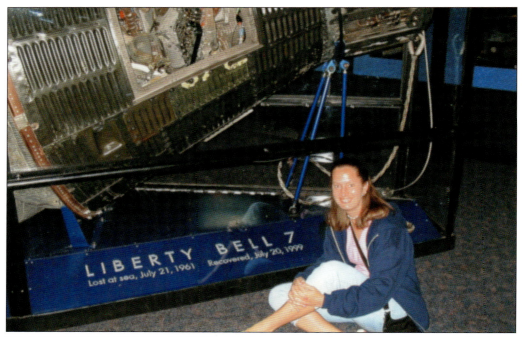

A science teacher extraordinaire and a passionate devotee of America's space exploration, Lisa DeWispelaere poses in front of the resurrected *Liberty Bell 7* on display at the research center in Hampton, Virginia. The recovered capsule now calls the Cosmosphere Museum in Hutchinson, Kansas, its permanent home. Lisa maintains her own educational website called spaceychick.com. (Paul DeWispelaere.)

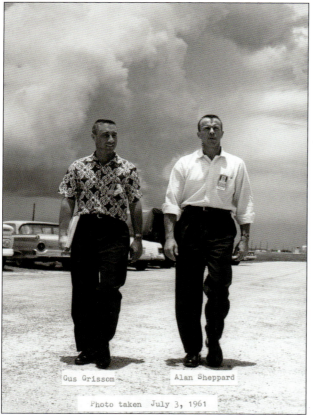

Here, Gus Grissom (left) and Alan Shepard are seen at training at Cape Canaveral. This July 3, 1961, photograph was taken 18 days before Grissom would join Shepard as the second American in space. Grissom flew 100 missions during the Korean War and received the Air Medal with Oak Leaf Cluster and the Distinguished Flying Cross for his service. Shepard was a Navy test pilot and flew a number of experimental planes, including the F3H Demon and F5D Skylancer. (NASA.)

Three
INTO ORBIT
JOHN GLENN LEADS THE WAY

When *Liberty Bell 7* sank to the bottom of the Atlantic, the common thinking at NASA was the need for one more suborbital flight before venturing into orbit. However, less than three weeks later, on August 6, the Soviets launched *Vostok II* with cosmonaut Gherman Stepanovich Titov, and he orbited Earth 17 times. The need to place a man in space now became more paramount than ever before, and thus, the pace was quickened to get America into orbit.

A review of the daily agenda and memoranda of John F. Kennedy will unveil that not a day passed during his administration where there was not some interaction regarding NASA and the exploration of space. He was actively involved and was constantly quizzing NASA personnel and the astronauts themselves on particulars of all aspects of space exploration.

Having served as backup to the flights of both Shepard and Grissom, Glenn got the call for America's first shot into orbit. Following his completion of the mission and safe return, President Kennedy held a press conference on the White House lawn. "This is the new ocean" said the president, "and I believe the United States must sail on it and be in a position second to none. Some months ago, I said I'd hope that every American would serve his country, today Colonel Glenn served his and we all express our thanks to him."

John Glenn's successful orbit of Earth catapulted him to legendary status not seen by the likes of the Wright brothers, Charles Lindberg, and Amelia Earhart combined. He was treated to ticker tape parades, a visit from the president at Cape Canaveral, and a White House reception, and he also addressed Congress. Shepard and Grissom accompanied him to the floor of the House where they took questions. Glenn was asked about the race to the moon. He responded, "These things would be worthwhile even if there were no such place as Russia. They are more than worthwhile for our own future, even if we were not in competition with anyone."

Speaking before the House Space Committee, Glenn's reflections turned poignant. "There will be failures, there will be sacrifices," Glenn told the lawmakers. "We don't envision every flight coming back as successfully as the three so far. I hope we all will continue to have the same confidence in the program that we have now, despite the fact there will be times when we are not riding such a crest of happiness and success as we are right now." His words would ring true in five years when Gus Grissom would become one of the first three astronauts to lose his life in a fire on the launchpad. Glenn would live to see the loss of both the crews of the space shuttles *Challenger* (1986) and *Columbia* (2003).

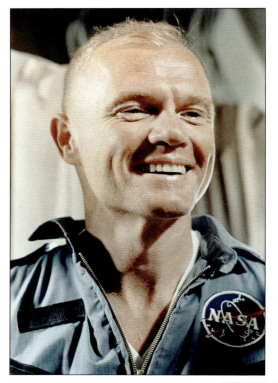

A Marine Corps aviator in World War II and Korea, John Glenn earned six Distinguished Flying Crosses and 18 Air Medals during his career. He flew in Korea with Baseball Hall of Famer Ted Williams and was named one of the original Mercury Seven astronauts. The backup pilot for both Alan Shepard's and Gus Grissom's flights, he was tapped to be the first American in orbit and became an instant American hero. He retired from NASA in 1964, having never flown in space again—in part because NASA did not want to risk the life of America's first orbiter. A US senator from 1974 to 1999, he returned to space on the shuttle *Discovery* in 1998 at the age of 77, the oldest person to fly in space. He passed away in 2016 at the age of 95, the last survivor of Mercury's original seven astronauts. (Both, NASA.)

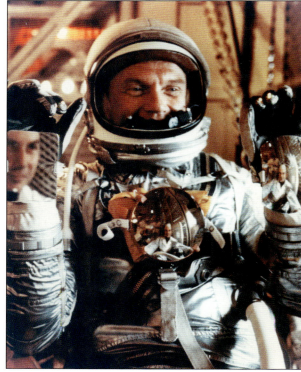

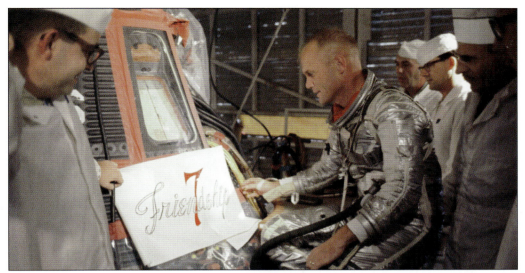

Each astronaut named his capsule. Keeping with the theme of including seven in the name (for the seven original Mercury astronauts), Glenn chose *Friendship 7*. He wanted it painted, not stenciled, and recruited artist Cecelia "Cece" Bibby to design and paint it. Bibby (below) became the first woman to enter the White Room at the top of the launchpad. In an interview with space.com in 2005, Bibby relayed the practical joke that Gus Grissom wanted to play on Glenn: "I painted a naked lady [on the capsule's periscope] with the caption that said, 'It's just you and me against the world, John Baby.'" The mission was scrubbed, and on his new launch day, Bibby explained, "I did another lady . . . She was a rather frumpy old lady in a house dress. She had a mop in one hand and bucket in the other. The bucket had 'Friendship' on it in the same script as his insignia on the capsule. . . . [its] caption read, 'You were expecting maybe someone else, John Baby?'" (Both, NASA.)

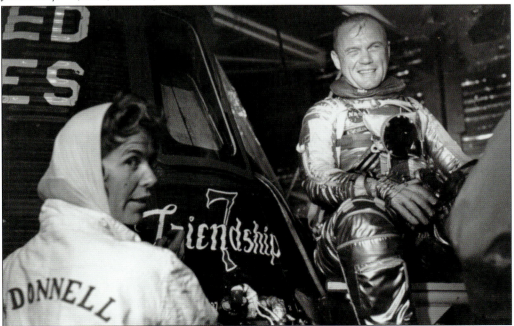

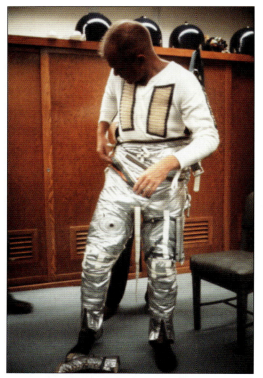

A launch was originally scheduled for January 16, 1962, but problems with the Atlas fuel tanks caused a postponement until January 20. A day-to-day postponement followed for a week of bad weather. Finally, on January 27, everything was good to go until cloud cover caused another postponement, 29 minutes short of launch. The reality of this delay was met with a sigh of relief by NASA as there was a sense that the spacecraft and booster were not quite ready to go. The next date was set for February 1, and the day before, a fuel leak was found, causing another delay of two weeks, until February 14. Bad weather once again intervened, and on February 18, the weather finally broke. On February 20, John Glenn suited up (left), boarded *Friendship 7*, and was launched. (Both, NASA.)

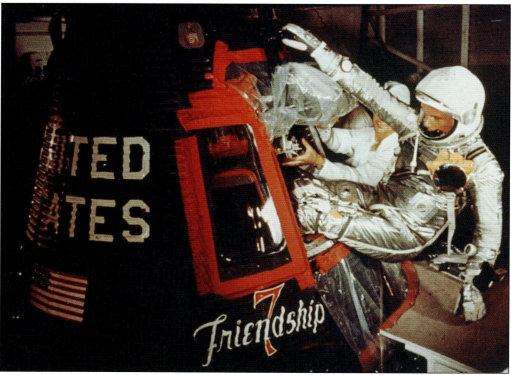

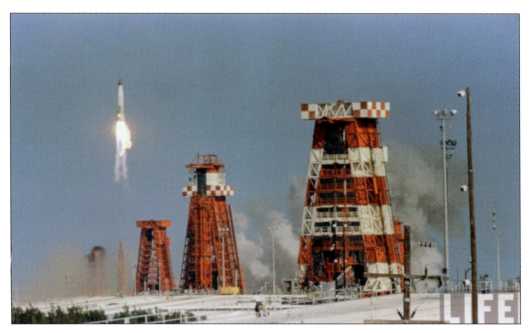

On February 20, 1962, at 10:47 a.m., *Friendship 7* was launched from Cape Canaveral, Florida, with John Glenn aboard, bound for space and Earth's orbit. JFK was aware of the difficulties *Friendship 7* had encountered and the opinion of some on the inside that it was "not quite ready" for launch. Below, Kennedy, along with, from left to right, Congressman Hale Boggs (Louisiana), Speaker John McCormick (Massachusetts) (blocked), Sen. Carl Albert (Oklahoma), Sen. Hubert Humphrey (Minnesota), Vice President Johnson, and Sen. Mike Mansfield (Wisconsin, right of television), watchs Glenn's launch with trepidation. (Above, Ralph Morse; below, JFK Library.)

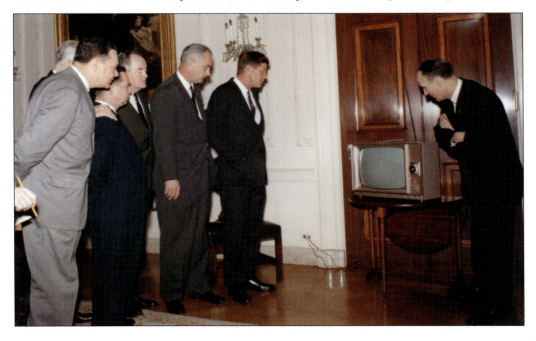

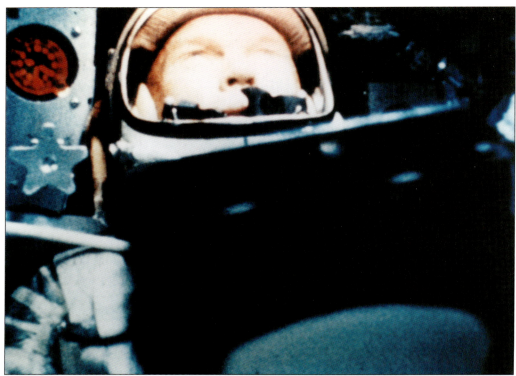

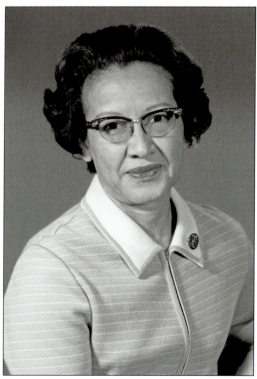

Glenn orbited Earth three times in a flight that lasted 4 hours, 55 minutes, and 23 seconds. The countdown was suspended three times for a total of 2 hours and 17 minutes, but 5 minutes after launch, Glenn entered Earth's orbit. One of the delays involved replacing a faulty component of the Atlas guidance system. Not trusting the computers, Glenn told the engineers to "get the girl" to run the same numbers through the same equations that had been programmed into the computer but by hand on her desktop mechanical calculating machine. "If she says they're good . . . then I'm ready to go." "The girl" was Katherine Johnson (left), whose story was told in the 2016 movie *Hidden Figures*. (Both, NASA.)

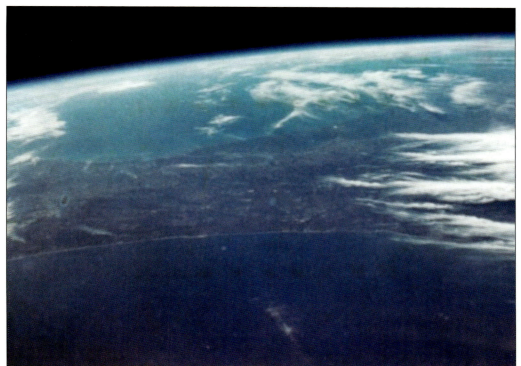

Three hours later, at the beginning of his third orbit, Glenn photographed this panoramic view of Florida from the Georgia border (right, under clouds) to just north of Cape Canaveral. At 162 miles above Earth, Glenn noted to Mission Control: "I have the Cape in sight down there . . . It looks real fine from up here. I can see the whole state of Florida just laid out like on a map. Beautiful." (NASA.)

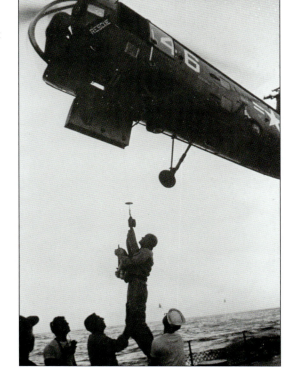

Here, Glenn is lifted into the recovery helicopter from the USS *Noa* for transfer to the USS *Randolph* and his return to Cape Canaveral. *Friendship 7* landed in the vicinity of Grand Turk Island about 800 miles southeast of Cape Canaveral. (NASA.)

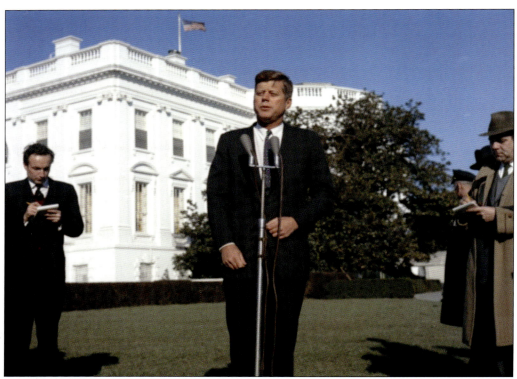

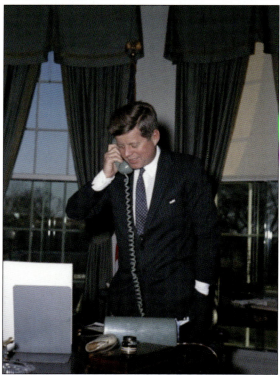

Immediately after the splashdown of *Friendship 7*, President Kennedy made his way to the Rose Garden to address the gathered White House press corps. The *Palm Beach Post* chronicled his words as follows: "John Glenn is the kind of American of whom we are most proud . . . I know I express the great happiness and thanksgiving of all of us that Colonel Glenn has completed his trip." Following this, the president went back into the White House and placed a call to the USS *Noa* and spoke to Glenn. "We're really proud of you and I must say you did a wonderful job," Kennedy said, "We're glad you got down in very good shape, I was just watching your mother and father on television and they seemed very happy . . . I'm going to come down to Canaveral on Friday and then hope you'll come up to Washington on Monday or Tuesday. I'll look forward to seeing you there." "Thanks Mr. President," Glenn said, "I certainly look forward to it." (Both, JFK Library, Knudsen.)

On Thursday, February 22, 1963, at 5:14 p.m., *Air Force I* landed at Palm Beach International Airport. Accompanying President Kennedy were Glenn's wife, Annie, and their children, David (16) and Lyn (14). A crowd of 10,000 people greeted the chief executive and Glenn's family, as the bands of Palm Beach and Forest High Schools played "Everything's Coming up Roses." JFK leads Annie (in a red hat), Lyn, and David down the ramp, where he introduced them to city officials. The following morning, Vice Pres. Lyndon Johnson accompanied Glenn as he flew into Patrick Air Force Base at Cape Canaveral, where his wife and children were waiting for him. In what the *Palm Beach Post* called the day's "best moment," Glenn greeted his wife, and "they held each other in a long embrace." (Right, JFK Library, Stoughton; below, AC.)

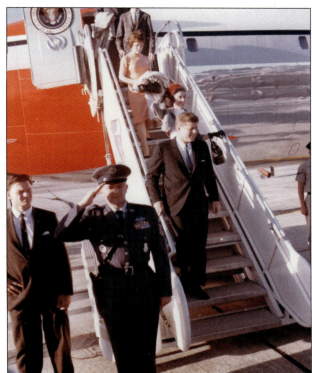

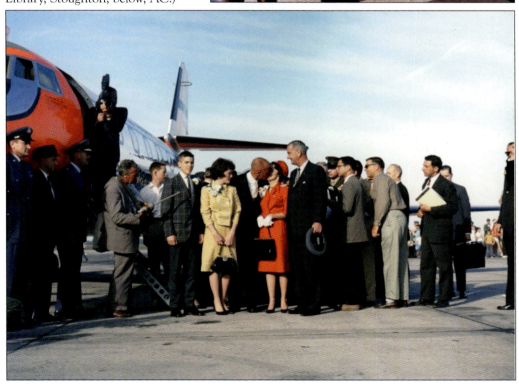

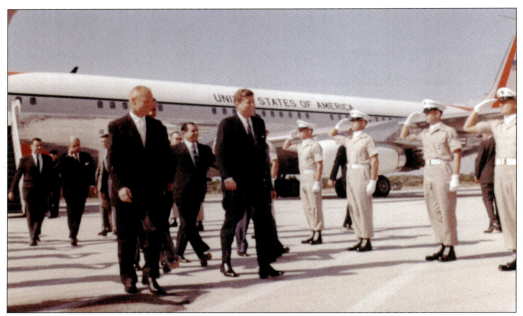

After the formal greeting, Glenn led JFK (above) to a "formal introduction" of his family. In his oral history at the JFK Library, Glenn recalled what followed: "Then he started off across to another area . . . The security wasn't very good . . . that day as far as crowd control was concerned . . . and it sort of got out of hand . . . He was right in the middle of the whole thing and he realized we weren't going to be able to get to where he had started to go. We turned and started back. The band . . . started playing 'The Marine Hymn' . . . the President said, 'Isn't that 'The Marine Hymn' they're playing?' and I said, 'Yes, it is.' He said, 'What do you normally do when they play [it]?' and I said . . . 'I normally stand at attention.' He said, 'That's what I thought,' and he stopped and stood at attention . . . and I stood beside him." (Above, JFK Library, Stoughton; below, JFK Library, Knudsen.)

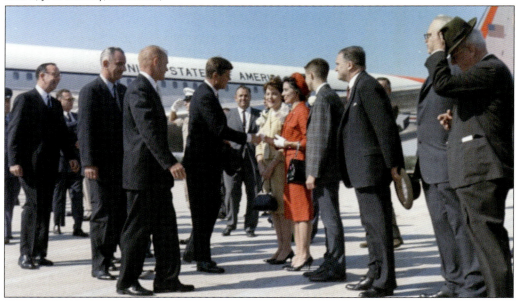

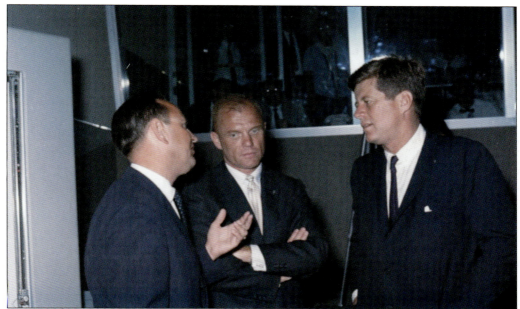

President Kennedy's first stop was the Mercury Control Center, where he received a briefing from Mercury flight director Chris Kraft (left) and John Glenn (center). "He was curious about all the different things at the Cape . . . [Kraft] who had been running the Control Center all the time I was in orbit, gave him a rundown on the various aspects of the Control Center and what everyone did. [Kennedy] was very interested in this, and particularly he was interested in meeting all the different people who had had a personal part to play in the whole flight." Among them was Alan Shepard. Following the briefing, the president and America's first man in orbit left the Mercury Control Center and made their way to Complex No. 14, which was where *Friendship 7* was launched just three days earlier. (Above, JFK Library, Stoughton; below, JFK Library, Knudsen.)

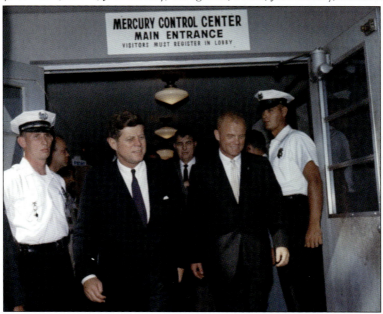

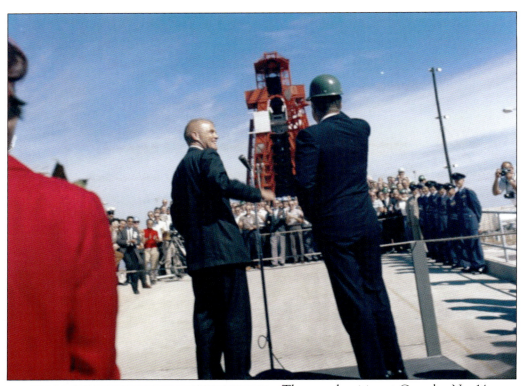

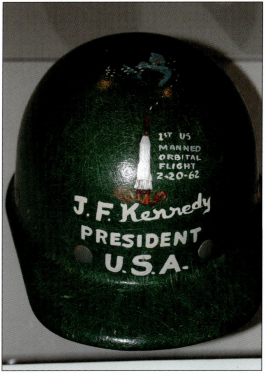

The crowd waiting at Complex No. 14 was comprised of the staff and workers who had played a major role in launching Glenn's *Friendship 7*. Glenn addressed the workers and presented President Kennedy with an honorary hard hat. Never one to don headgear of any kind, especially while in the performance of his official duties as president, JFK wore this hat with particular pride when Colonel Glenn placed it upon his head. Glenn recalled, "We presented him with a missile hat down there and I know he wasn't much for putting on Indian headdresses and things like this . . . but we presented him with this missile hat and he took that with him." The hard hat is now on display at the JFK Museum at the JFK Library. (Above, JFK Library, Knudsen; left, RPS.)

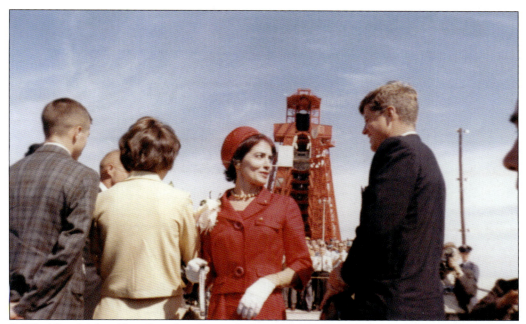

Still holding his hard hat, President Kennedy shares a moment with Annie Glenn as they prepare to leave Complex No. 14 and make their way to Hangar S, where Kennedy will present her husband with the NASA Distinguished Service Medal. David and Lyn Glenn are in the left of the photograph with their dad (partially blocked) between them. (JFK Library, Stoughton.)

The president and Lt. Col. John Glenn glance at the launchpad that propelled Glenn into orbit. JFK's hard hat is perched on the back of the seat as they begin their ride to Hangar S. Both men were gratified and relieved at the success of the mission. (JFK Library, Stoughton.)

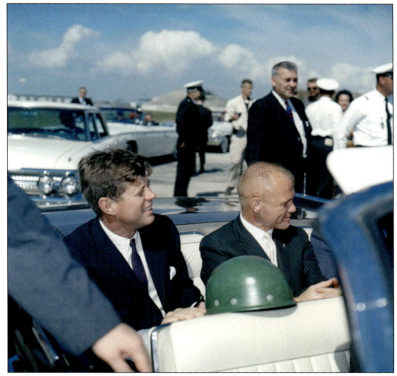

59

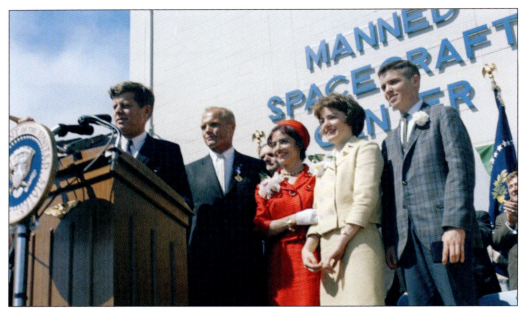

At 11:25 a.m., NASA director James Webb took the podium at Hangar S and introduced Vice Pres. Lyndon Johnson, who, after a few brief remarks, introduced President Kennedy. Kennedy began by introducing Glenn's family to the gathering. From left to right behind the president are Glenn; his wife, Annie (in red); his daughter, Lyn; and his son, David. He introduced Glenn's parents saying, "They launched him, originally." (JFK Library, Stoughton.)

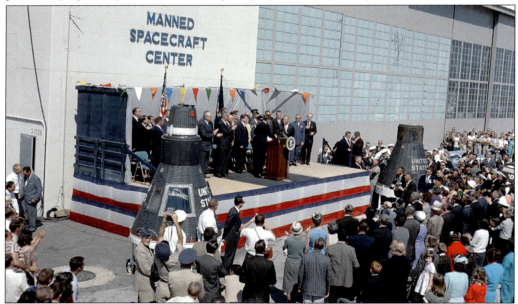

JFK presented a medal to Dr. Robert Gilruth, who led the team of scientists and engineers, and then called on Glenn saying, "His performance was marked by his great professional knowledge, his skill as a test pilot, his unflinching courage and his extraordinary ability to perform . . . under conditions of great physical stress and personal danger. His performance fulfillment of this most dangerous assignment reflects the highest credit upon himself and the United States." (NASA.)

In the humble manner that came to personify John Glenn he said, "I can't express adequately my appreciation to be here accepting this . . . thousands and thousands of people have contributed certainly as much or more than I have to the project . . . I am very proud of the medal, for all of us, you included, because I think it represents all of our efforts, not just mine." (JFK Library, Stoughton.)

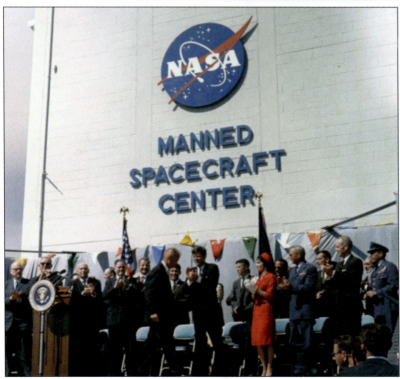

As Glenn leaves the podium, the president joins the throng standing to applaud his effort. In his opening remarks, JFK noted that the date marked the 17th anniversary that "a group of Marines put the American Flag on Mount Suribachi [Iwo Jima]." He went on to say, "In the not too distant future, a Marine or a Naval man or an Air Force man will put the American flag on the moon." (JFK Library, Knudsen.)

61

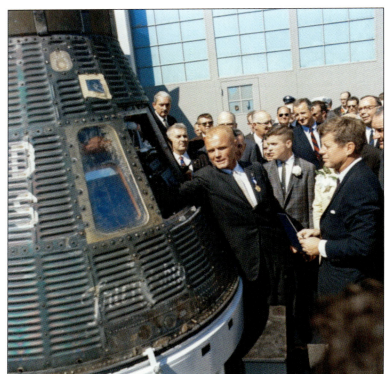

Glenn shows the president his capsule. He remembered the following of JFK: "He was interested in the whole program, not just in specifics on an individual flight . . . where one part of the project led on to another . . . what followed beyond my flight and what we would do that's different on the next flight . . . were we going on to new things on each flight? . . . What new things . . . and [he] asked very detailed questions about them." (JFK Library, Knudsen.)

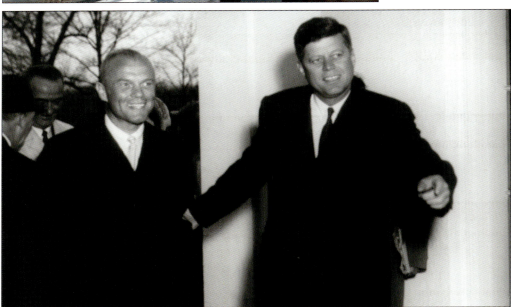

The Glenns flew back with the first family on *Air Force One* the following Monday for a White House reception and DC parade. Here, JFK escorts Glenn into the Oval Office. On the flight back, Caroline Kennedy was introduced to Colonel Glenn. Having heard of all the spaceflights, she curtsied upon her introduction to the astronaut, looked up at him, and asked, "Where's the monkey?" (JFK Library, Rowe.)

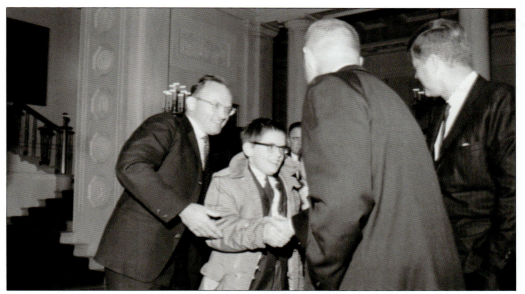

Colonel Glenn was a huge hit with everybody, including the children, nieces, and nephews of high government officials. In the photograph above, Glenn shakes hands with McGeorge Bundy's 11-year-old son Stephen at the White House. Bundy was JFK's national security advisor and is standing behind Stephen. The photograph below, taken in the Oval Office, shows Glenn drawing the route of his flight and then autographing it. It is the American Geographical Society's (AGS) Fliers' and Explorers' Globe. Looking on are President Kennedy, Lyndon Johnson, AGS director Charles B. Hitchcock (glasses), and several children, including President Kennedy's nephew Robert F. Kennedy Jr. in front of JFK. (Above, JFK Library, Stoughton; below, JFK Library, Knudsen.)

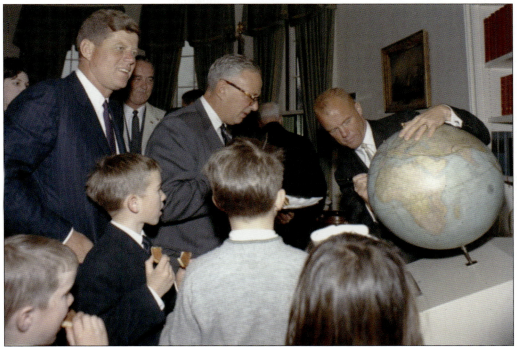

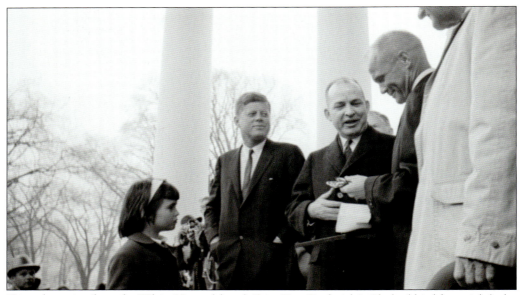

Upon departing from the White House (above), Brig. Gen. Frederick J. Clarke (third from right), the engineer commissioner for the District of Columbia, gave Glenn a key to the city. Looking on are Maria Shriver and her "Uncle Jack." Glenn then joined a motorcade (below) with his wife, Annie; Vice President Johnson; and his children up Pennsylvania Avenue to address a joint session of Congress. Making front-page news once again, the *Palm Beach Post*, under the headline "Glenn Sees Tremendous Benefits In Space Trips, Asks God Guide Knowledge Gained In Flights," chronicled the hero's story. Glenn received two standing ovations before he even began his speech. Speaking for 16 minutes, he echoed the vision of JFK when he said, "Exploration, knowledge and achievement are good only insofar as we apply them to our future . . . Progress never stops, we are now on the verge of a new era." (Above, JFK Library, Stoughton; below, JFK Library, Knudsen.)

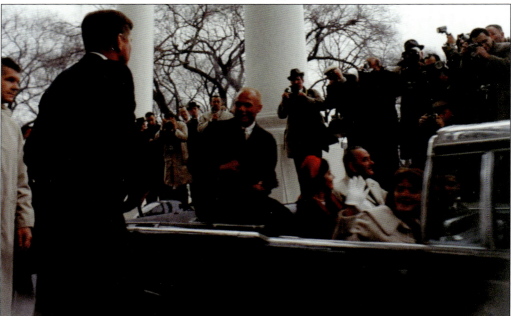

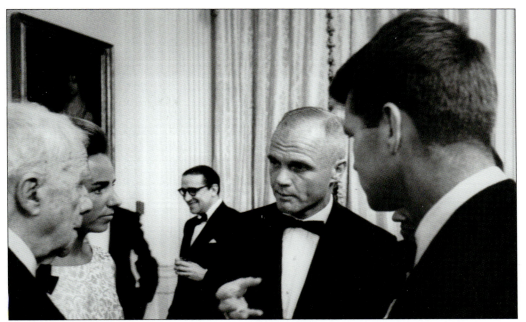

Glenn would return to the White House on April 29, 1962, when Nobel Peace Prize winners were honored at a White House reception in the East Room. Here, Glenn chats with Robert Frost, Ethel Kennedy (to Frost's left), and Atty. Gen. Robert Kennedy. Glenn felt a close bond with President Kennedy but became very good friends with Robert. (JFK Library, Stoughton.)

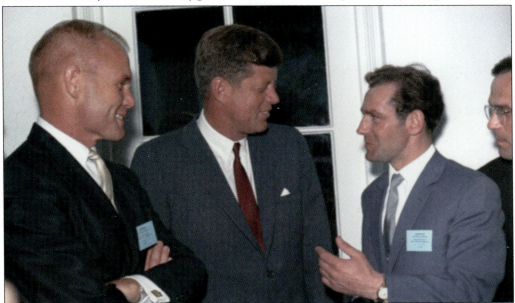

Four days later, Glenn was back, and with President Kennedy, he welcomed Russian cosmonaut major Gherman S. Titov to the White House. Seen here with his interpreter Ivan Shklyar (right), Titov chats with the president and Glenn. Titov and his wife joined Glenn's family at Glenn's home in Arlington, Virginia, and helped the astronaut grill the steaks for their meal together. (JFK Library, Knudsen.)

Deke Slayton (right) was originally slated to follow Glenn into orbit; however, in March 1962, he was grounded by NASA due to atrial fibrillation, an irregular heartbeat. He would serve in an administrative capacity with NASA until regaining flight status in 1972. In 1975, he served as the docking module pilot in the only joint US/Soviet space effort. His Soviet counterpart was Alexey Leonov. (NASA.)

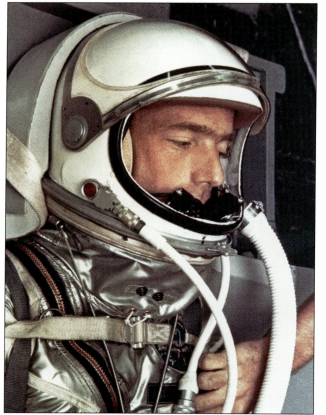

Scott Carpenter filled the breach left by Slayton. He had served as Glenn's backup for *Friendship 7*. A witty fellow, Carpenter was speaking to Glenn from the blockhouse and said to him as he awaited liftoff, "Remember John, this was built by the low bidder." Then, at ignition, it was Carpenter who uttered the words, "Godspeed, John Glenn," a phrase that became a cornerstone in the lexicon of NASA. (NASA.)

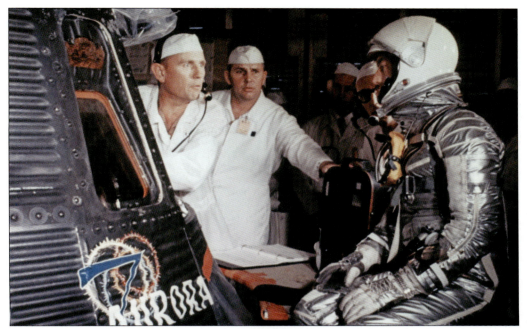

Carpenter named his craft *Aurora 7* for the open sky of dawn, symbolizing the dawn of a new era. He also grew up on the corner of Aurora and Seventh Avenues in Boulder, Colorado. Carpenter's flight was similar to that of Glenn's, orbiting three times. He did, however, overshoot his targeted splashdown spot by about 250 miles and floated for an hour awaiting a chopper pickup. (NASA.)

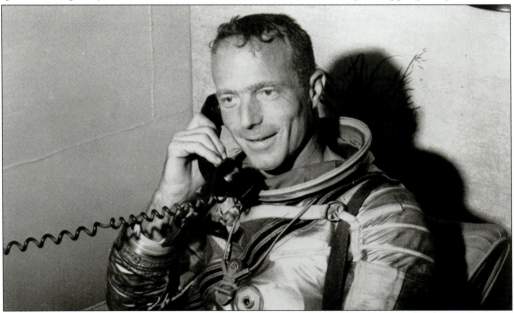

Carpenter, safely aboard the USS *Intrepid*, talks with President Kennedy: "I want to tell you we are relieved and very proud of your trip. I am glad that you got picked up in good shape, and I want to tell you we are all for you," the president told him. Carpenter responded with an apology "for not having aimed a bit better on re-entry." (NASA.)

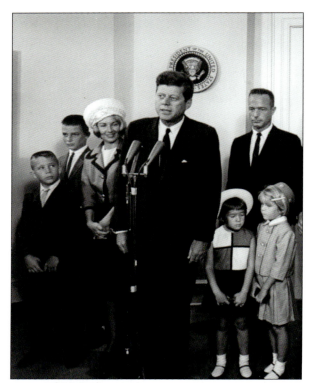

On June 5, 1962, JFK welcomed Carpenter and his family to the White House. In introducing them, he said the following: "It is a source of great satisfaction to me as president at this time in our history to have these Americans [the astronauts and their families] . . . Who represent our country." Pictured are, from left to right, Robyn, Marc, Rene, President Kennedy, Candace, Kristen, and Scott Carpenter. Carpenter then spoke: "The main feeling I came back with was one of awe and inspiration. The feeling I have now, in the aftermath of the flight, is one of humility." Acknowledging with gratitude the support the entire country gave to the Mercury program, he asked for its continuation. "We stand to gain more, from what we will learn as a result of spaceflight, than any undertaking that men have made." (Left, JFK Library, Rowe; below, JFK Library, Stoughton.)

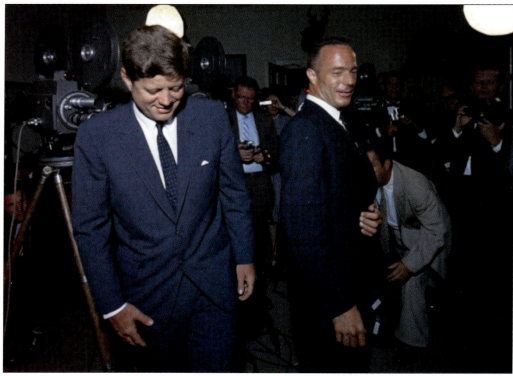

Four

THE PRESIDENT'S COMING
JFK WANTS TO KNOW

With the success of the missions of Glenn and Carpenter, the United States was energized for space, and there was nobody more so than President Kennedy. In September, he slated a visit to the four facilities, which were enmeshed in NASA's space efforts, to inspect and be briefed on the current state of America's moon quest. A two-day excursion was scheduled, and on September 11, 1962, the president and the vice president left Andrews Air Force Base on two different planes. Thirty-five members of the presidential entourage were dispersed between the two aircraft bound for Huntsville, Cape Canaveral, Houston, and St. Louis.

Kennedy's curiosity for details, which Alan Shepard and John Glenn had observed, was never more evident than on this trip. It was on this trip that he reenergized his commitment toward reaching the moon. This was evident in an 18-minute speech before 50,000 people at Rice Stadium on the campus of Rice University. He challenged America in the same way he did in his inaugural address in regards to the nation's quest for the moon.

Two more Mercury flights awaited, but it was clear that what lay ahead was a full-scale effort to reach the moon and do so before 1970. There were detractors to be sure, political and otherwise, but the energy created by this effort was palpable and spread throughout the free world. School kids of all ages wrote letters of support and sent money, as did families. Hundreds and hundreds of letters of encouragement and support sit in the archives of the JFK Library, illustrations of the stirred imaginations of people throughout the world.

On Saturday morning, November 16, 1963, President Kennedy made his last visit to Cape Canaveral. The following week, he was going to Texas, stopping in five cities in just two days—San Antonio and Houston on Thursday and Fort Worth, Dallas, and Austin on Friday. Several Texas cities would play a key role in America's space efforts, and the president was looking forward to reporting to them the current status of "the greatest adventure upon which man has ever embarked."

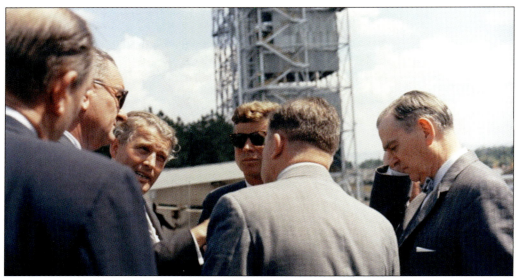

In Huntsville, JFK probed the mind of Wernher von Braun (third from left above and left below), who added his name to the list of individuals who were impressed by the president's insatiable appetite for knowledge. "He took a great personal interest in every detail of the program . . . I was using a little model of the Saturn V/Apollo . . . to explain to the President how, step by step, the entire trip from the surface of the earth to the moon and back would proceed . . . he [Kennedy] wasn't a technical man but to him it was so very obvious that space was something that we simply could not neglect . . . we just had to be first in space . . . this was a challenge as great as that confronted by the early explorers of the Renaissance . . . he found it difficult to understand why some people couldn't see the importance of space," said von Braun. (Both, Knudsen.)

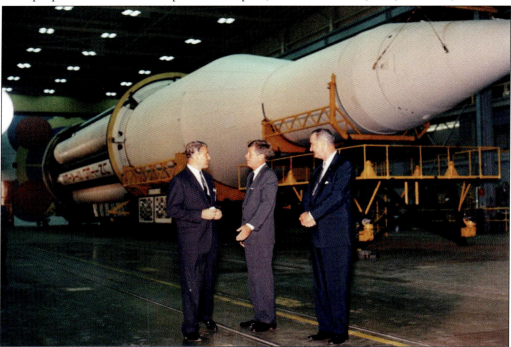

At the president's request, von Braun joined him for the trip to Cape Canaveral. Here, JFK (in sunglasses) is briefed by Col. Dan F. Thompson (center) on the particulars of the *Titan II*, standing majestically in the background. The *Titan II* would launch the 12 missions of Gemini—none of which JFK would see. (Stoughton.)

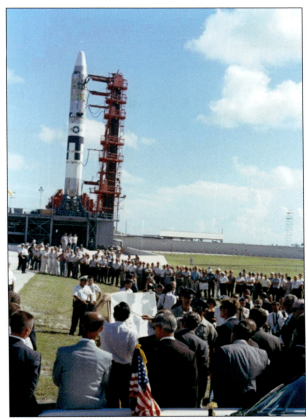

Among the trademarks of President Kennedy was his propensity to mingle with a crowd; he virtually never lost the opportunity to simply greet the people. He always reached out to the local police, who aided in every security effort that protected him. During this four-stop space tour, he took time to acknowledge and greet the workers at every facility. Here, he says hello to the Cape Canaveral workers. (Knudsen.)

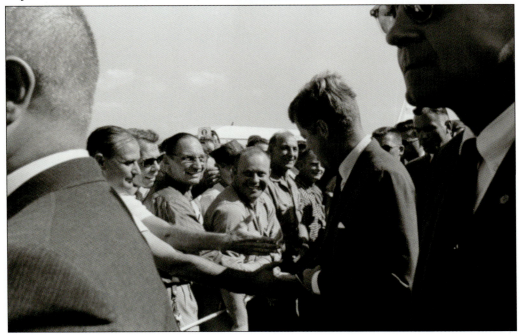

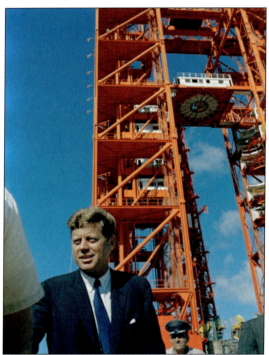

The president shakes the hand of an unidentified man while visiting the Saturn Launch Site under construction at Cape Canaveral's Launch Complex No. 37. The president picked the brains of NASA personnel and was constantly looking forward. He was very encouraged when von Braun told him that the moon mission could be accomplished by 1967 or 1968. The key, of course, was funding. (Stoughton.)

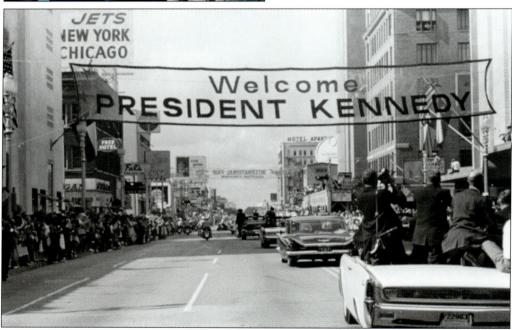

From Cape Canaveral, it was on to Houston where JFK received the key to the city before settling down in the Rice Hotel for the night. The following morning, he was bound for Rice University and a speech at the football stadium but not before a motorcade through downtown Houston. He is seen standing in the lead car. Riding with him was Robert Gilruth, NASA director of the Manned Spaceflight Center. (Knudsen.)

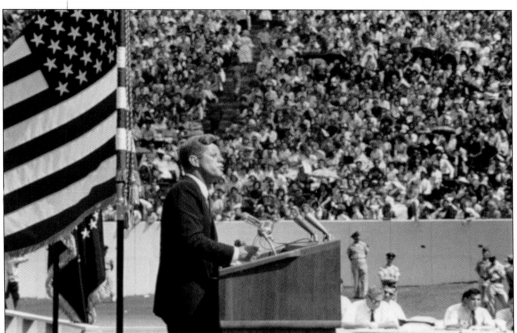

In his speech, JFK rededicated the United States' commitment to reaching the moon by 1970. He opened with the recognition of the fast pace of the world, and he did so by placing human history in a time line of but a half century. "Stated in these terms," he offered, "we know very little about the first forty years . . . ten years ago man emerged from his caves . . . five years ago man learned to use a cart with wheels . . . Christianity began less than two years ago . . . Less than two months ago . . . Newton explored the meaning of gravity . . . Last month electric lights . . . automobiles . . . and airplanes became available . . . Only last week did we develop penicillin . . . television and nuclear power." He outlined the perils, dangers, and costs of space exploration while continually articulating the United States' intent to move forward. He then went to inspect the proposed Apollo lunar module (behind him in the photograph at right), which was known then as the "Bug." (Both, Stoughton.)

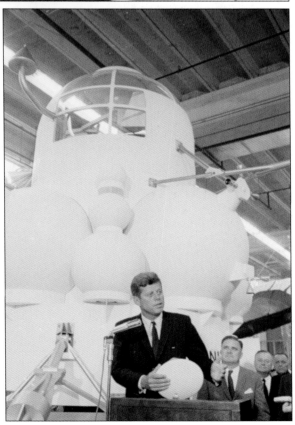

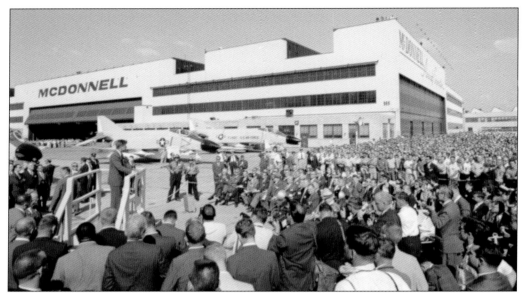

The final stop on his inspection tour was the McDonnell Aircraft Corporation in St. Louis, where the president addressed 10,000 employees. He echoed his morning message in Texas. Extolling the virtues of their efforts to "put one man or two men, first in orbit around the earth, and then in orbit around the moon, and then on the moon and then come back . . . No action, no adventure is more essential . . . more exciting, than to be involved in the most important and significant adventure than any man has been able to participate in, in the history of the world and it's going to take place in this decade." What followed was a 45-minute top-secret briefing and a visit inside to look at the mock-up of the two-man Gemini capsule, the next phase of the quest for the moon. (Both, Stoughton.)

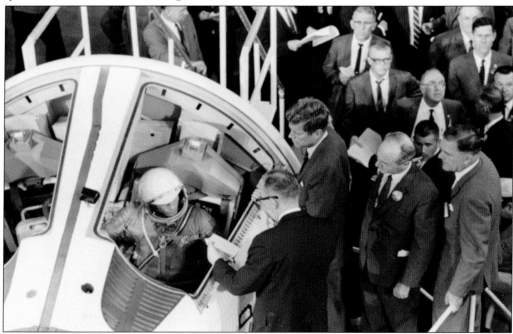

While at Cape Canaveral, astronaut Wally Schirra briefed President Kennedy on his upcoming flight aboard *Sigma 7*. Three weeks later, Schirra became the fifth American in space and the third to orbit when in 9 hours, 13 minutes, and 11 seconds, he orbited Earth six times, doubling the duration of Glenn and Carpenter. His focus was the engineering and human factors in manually operating the space capsule. (This would prove essential when Armstrong landed on the moon, as he had to take manual control over the *Eagle*.) When Schirra spoke to JFK from the deck of the USS *Kearsauge* following his flight, he thanked him for "coming down and giving our booster a blessing." On October 16, Schirra and his family were received by the president. Unbeknownst to anyone, on this very day, Russian missiles were found in Cuba. (Both, Stoughton.)

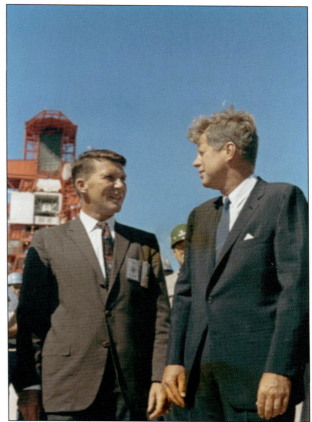

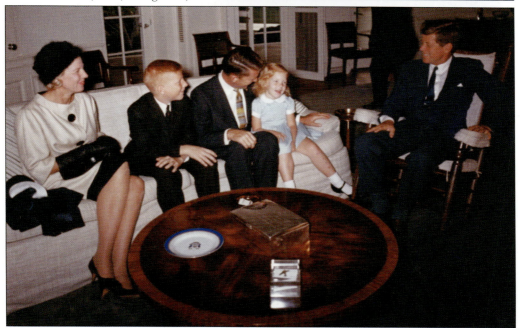

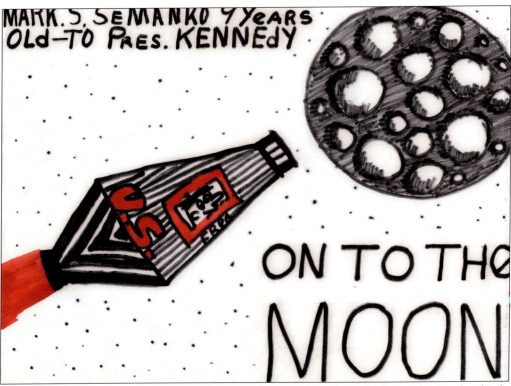

In late October 1962, President Kennedy received an envelope from the Semanko family of Bala Cynwyd, Pennsylvania. Included was the above work of art, a check for $27 (earmarked for the "Race to the Moon"), and letters from mom and three of her five sons, Edward (14), Mark (9), and Peter (7). Edward sent $5 from his paper route; Mark $3 from selling pot holders, which he made himself; and Peter $3 from his "bank." Peter told the president, "We want Americans on the moon," while Mark "prayed Americans get to the moon first." Edward expressed his desire to become an electrical engineer and hoped to work for NASA. The White House received thousands of similar communications, donations, and "space" gifts, including the model of the Gemini capsule below, a Christmas gift from the personnel of McDonnell Aircraft Corporation. Pictured are, from left to right, Brig. Gen. Godfrey T. McHugh, Kennedy, and Gen. Chester V. Clifton (in the doorway). (Above, JFK Library, Mark Semanko; below, JFK Library, Knudsen.)

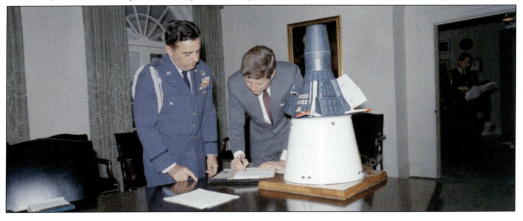

On May 15, 1963, Gordon Cooper made the last spaceflight in the Mercury program, orbiting Earth 22 times and covering 600,000 miles in 34-plus hours. He became the first American to sleep in space. He asked and received permission to remain in the capsule until it was hoisted on the deck. Here, he is seen backing out of his spacecraft *Faith 7* on the USS *Kearsarge*. Later in his life, Cooper spoke openly about his confrontations with UFOs as a pilot. Fellow astronauts and moonwalkers Ed Mitchell and "Buzz" Aldrin also spoke out about similar experiences and their belief that humans are not alone. Ever a free spirit, in the image below, taken at the White House with his fellow astronauts and their wives, Cooper plopped down in JFK's famous rocker for the photograph to the delight of all, especially the president. (Right, NASA; below, Stoughton.)

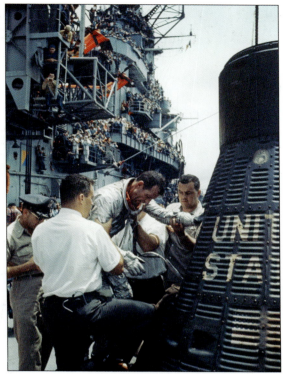

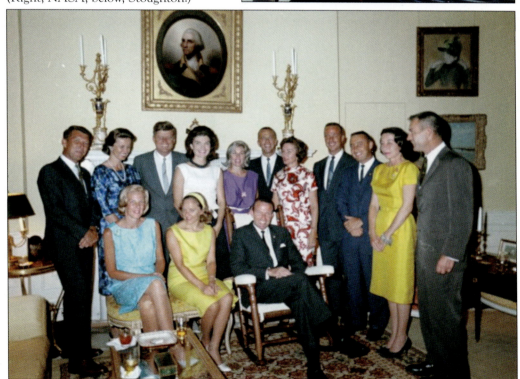

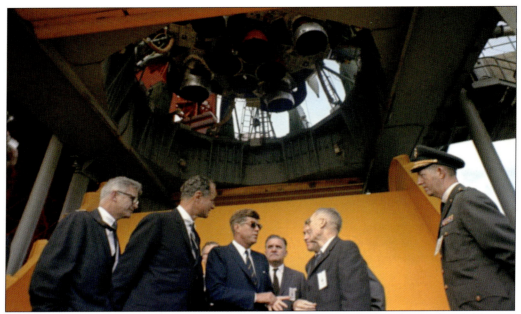

On November 16, 1963, JFK made his last visit to Cape Canaveral, where he was briefed by von Braun (third from right, partially hidden) on the development of the Saturn rocket. Here, he gathers beneath the behemoth at Pad B, Complex No. 37, with, from left to right, Dr. Robert Seamans (NASA), Florida senator George Smathers, unidentified, NASA director James Webb, Hugh Dryden (NASA), and JFK aide General Clifton. (Stoughton.)

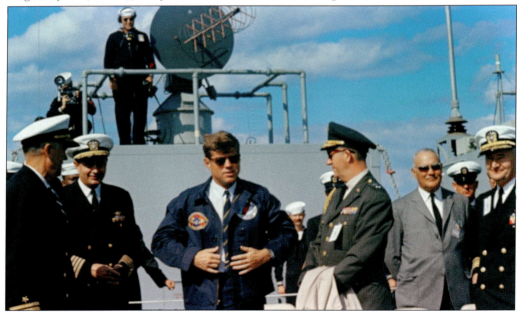

Before leaving the Cape, he invited von Braun and his wife to the White House. A dinner meeting was set for Monday, November 25. JFK then choppered to the deck of the USS *Observation Island* to witness the test launch of a Polaris missile. He was given a flak jacket upon arrival, which he immediately donned. (Stoughton.)

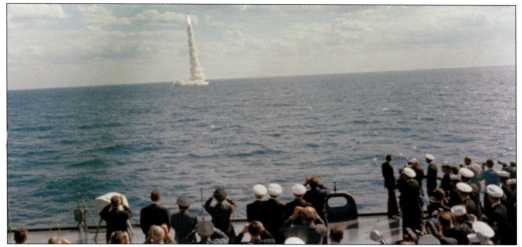

On the deck, the commander in chief watches (through binoculars, front right) the successful launch of the Polaris A2 missile from the submarine USS *Andrew Jackson*. Following the successful launch, the president called the captain of the *Andrew Jackson* to congratulate and encourage him. (Stoughton.)

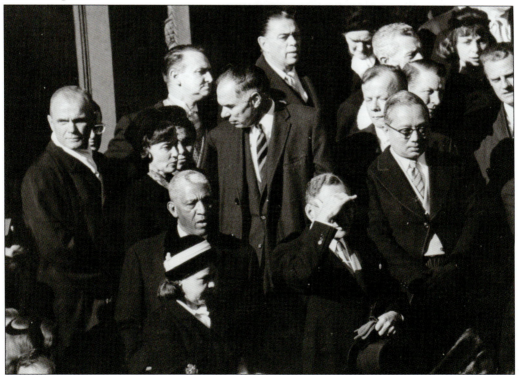

Dr. Wernher von Braun did not make dinner at the White House on November 25, 1963. For on that day, John F. Kennedy was laid to rest. John Glenn (far left) was present at the funeral. JFK's undelivered Dallas Trade Mart speech ended with the following: "Our national space effort represents a great gain in, and a great source of, our national strength. And both Texas and Texans are contributing greatly to that effort." (Stoughton.)

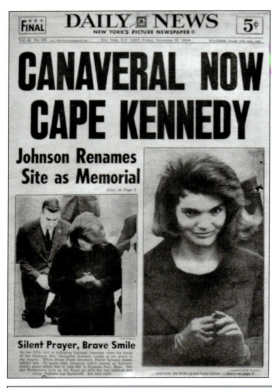

Three days after the burial of President Kennedy, Pres. Lyndon Johnson announced that Cape Canaveral would be renamed Cape Kennedy in memory of the slain president. The following day, Johnson issued an executive order that all facilities on Merritt Island and Cape Canaveral be renamed the John F. Kennedy Space Center. In May 1973, the Florida Legislature officially changed the name back to Cape Canaveral, which the US Board of Geographic Names recognized five months later. The name for the facilities remained the John F. Kennedy Space Center, and since then, the official name has been, the John F. Kennedy Space Center at Cape Canaveral, Florida. All that notwithstanding, it was from the launchpads seen below that every Gemini flight and every Apollo flight took Americans from Cape Kennedy, Florida, to the moon. (Left, AC; below, NASA.)

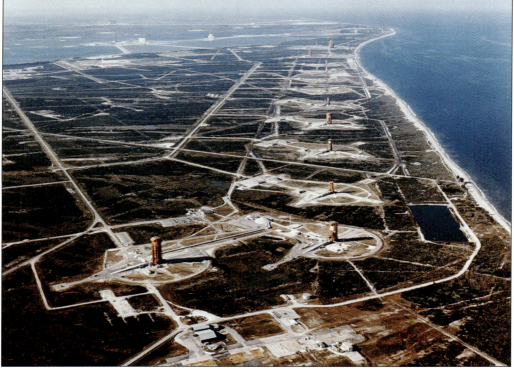

Five

The Original Seven
JFK and the Mercury Astronauts

On September 12, 1962, Vice Pres. Lyndon Johnson stood before 50,000 people in Rice University Stadium in Houston, Texas, and introduced President Kennedy. In an 18-minute speech, John F. Kennedy rearticulated his vision for the United States to reach the moon and revitalized his commitment to do so.

Kennedy's leadership in this endeavor and his interest in America's quest went far beyond the superficial, romantic aspects of exploring the stars. His interest was deep and abiding in each and every aspect of the program. His thirst for knowledge on all levels was something that was not lost on those involved in it. "He took a great personal interest in every detail of the program," recalled von Braun. John Glenn remembered, "He was interested in real detail," and as for the safety of the astronauts, Glenn said, "An interest in one human being to another—as one 'guy' to another, if you will." Alan Shepard noted, "He always seemed, when we discussed the program to be extremely interested in it . . . and even in some of the details of how the flight controllers reacted . . . responded, what their jobs were and so on."

President Kennedy was deeply involved and briefed on all phases of the quest for the moon, Mercury, Gemini, and Apollo. He would never see a Gemini manned flight, as the first one would take place in March 1965. But he forged a bond with Mercury's original seven astronauts and, in so doing, created a legacy that, more than a half century later, continues to inspire and to teach. All of them are gone now, yet they remain inexorably linked as they laid the cornerstones of American space travel.

President Kennedy, Gus Grissom, and John Glenn share eternal sleep in the hallowed ground of Arlington National Cemetery, America's most sacred ground. By the 50th anniversary year of *Apollo 11*'s moon landing, 22 other astronauts had been laid to rest in Arlington as well. The aforementioned Grissom and Glenn are the only two of the original seven interred at Arlington; however, seven of the 17 who died in the exploration of space are buried in this revered ground of heroes.

Kennedy's words still beckon to us, cascading across the rolling hills, across the decades of history. They echo the challenge; they whisper the tragedy; they exult in the triumph. They cling to the soul of a nation who, for a brief moment in time, dared to look to the stars and then reach them.

Inscribed in granite at the gravesite of the man who led his country to that challenge are the closing words to his inaugural address. "With a good conscience our only sure reward, with history the final judge of our deeds, let us go forth to lead the land we love, asking His blessing and His help but knowing that here on earth God's work must truly be our own."

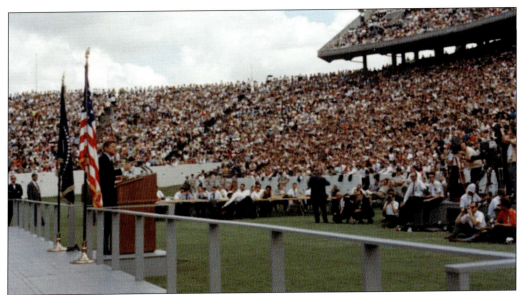

At Rice University, JFK closed his speech invoking the words of an explorer: "Many years ago, the great British explorer George Mallory, who was to die on Mount Everest, was asked, why did he want to climb it. He said, 'Because it is there.' Well space is there and we are going to climb it. And the moon and the planets are there . . . And therefore as we set sail, we ask God's blessing on the most hazardous and dangerous and greatest adventure on which man has ever embarked." (JFK Library, Knudsen.)

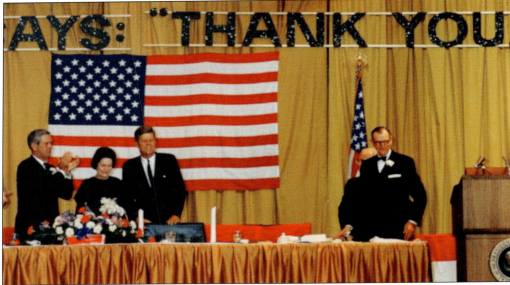

Sharing the dais with JFK in Houston in 1963 are, from left to right, Governor Connolly, Ladybird Johnson, and Congressman Albert Thomas. The president spoke at a dinner for Thomas and looked to the future: "In 1990, the age of space will be entering its second generation, and our hopes to preserve it for peace . . . to prevent its military exploitation or its commercial domination by an unfriendly power, depend upon the effort we are willing to mount now here in Houston and across the country." He was assassinated the next day in Dallas. (JFK Library, Stoughton.)

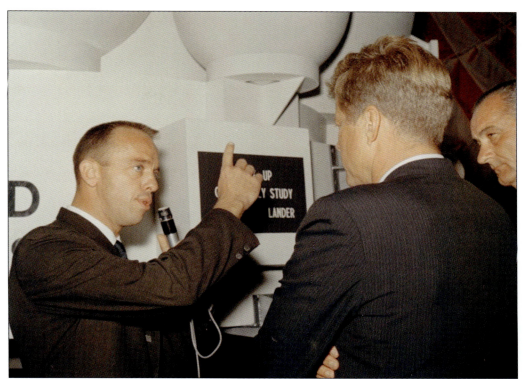

On September 12, 1962, Alan Shepard briefed President Kennedy and Vice President Johnson at the Manned Spacecraft Center in Houston. He briefed them on the mock-up of the Apollo lunar lander, known then as the "Bug." Shepard, who piloted America's first flight, was targeted for the first Gemini flight but was grounded with Ménière's disease. In 1968, a surgical cure was developed, and Shepard was restored to full flight status. On February 5, 1971, he became the only Mercury astronaut to walk on the moon (right) as the commander of *Apollo 14*, hitting two golf balls while doing so. Shepard died in 1996, and his wife followed him five weeks later. Their ashes were scattered in Stillwater Cove, California, and a cenotaph memorializes them at Forest Hill Cemetery in East Derry, New Hampshire, Shepard's hometown. (Above, JFK Library, Knudsen; right, NASA, Edgar Mitchell.)

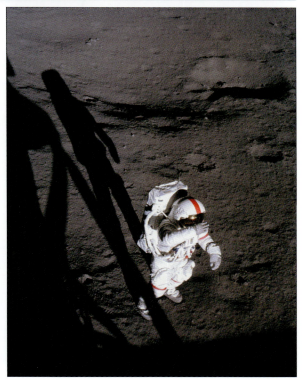

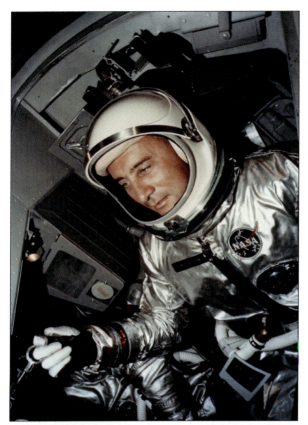

Grissom, seen here before launch, replaced Shepard as the commander of *Gemini III*, and America's first two-man spacecraft was launched on March 23, 1965. Its mission was to simply test the maneuverability of the craft in space. Grissom and John Young successfully completed three orbits. Grissom called his ship the *Unsinkable Molly Brown* in a parody of his *Liberty Bell 7*, which sank when its hatch blew prematurely. (NASA.)

Grissom was named commander of *Apollo 1* to begin the final leg of the journey to the moon. However, a flash fire on the launchpad during a training exercise on January 27, 1967, took his life and those of Edward White (center) and Roger Chaffee (right). The first casualties of American spaceflight, this special tribute to them opened at the Kennedy Space Center on the 50th anniversary of their deaths. (NASA, Kim Shiflett.)

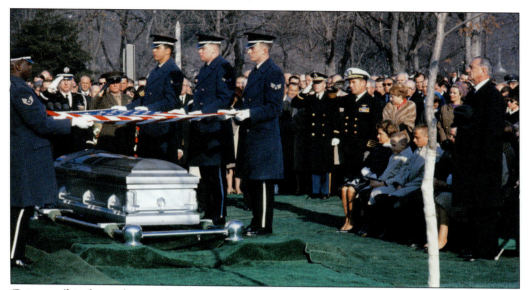

Grissom (his funeral seen above) and Chaffee were interred side by side, joining President Kennedy in eternal rest in Arlington National Cemetery. White was buried at West Point. After his Gemini flight, Grissom said, "If we die, we want people to accept it. We are in a risky business and we hope that if anything happens to us it will not delay the program. The conquest of space is worth the risk of life." (NASA.)

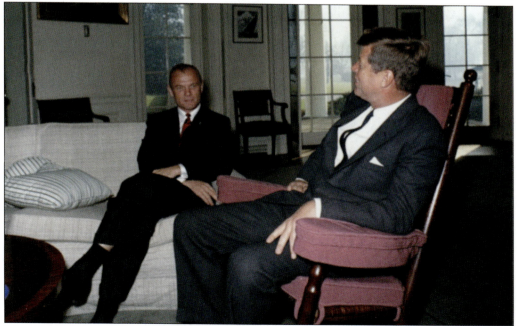

John Glenn first met President Kennedy at the White House on February 5, 1962. Glenn remembered the following about JFK's curiosity about the launch: "He was interested very much in the anticipated G level . . . what kind of sensations we expected . . . what kind of control we had . . . were we actually going to drive it . . . what pressures we would be operating under, what we would do if the pressure in the spacecraft failed. He was interested in real detail." (JFK Library, Knudsen.)

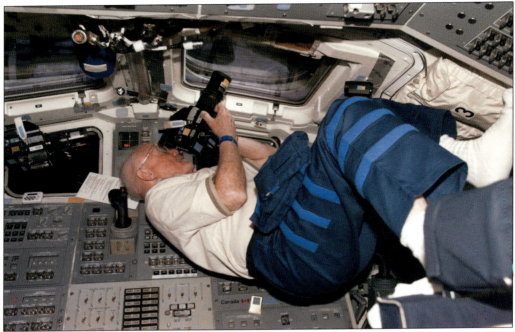

Glenn retired from NASA in 1964; however, on October 29, 1998, at 77, he returned to space as a payload specialist aboard the shuttle *Discovery*. Somewhat of a guinea pig for geriatric space studies, Glenn was also in charge of the flight's photography and videography. He would live to be 95 years old and was the last living Mercury astronaut when he passed in 2016. (NASA.)

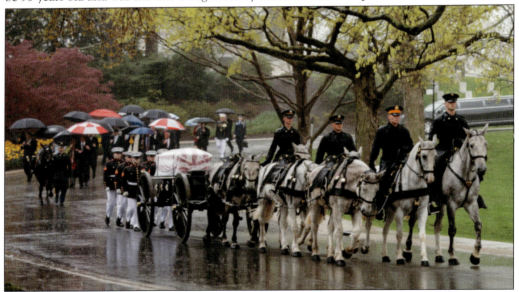

John Glenn joined John F. Kennedy in eternal rest at Arlington. NASA administrator Robert Lightfoot said the following of him: "He was the hero we needed in a rapidly changing world and an icon of our American spirit. We will never forget him, and future generations will continue to live out his legacy as we venture farther into the solar system. God speed, Senator Glenn. Our deepest gratitude, and everlasting respect and affection go with you." (NASA.)

Aurora 7 would be Scott Carpenter's only foray into space. Carpenter said, "I was more interested in what was there than what got us there." So fascinated and taken by the experience of being in space, Scott neglected the details required to safely reenter. He fired his reentry rockets three seconds late, causing him to miss his landing zone by 250 miles. He never flew again. (NASA.)

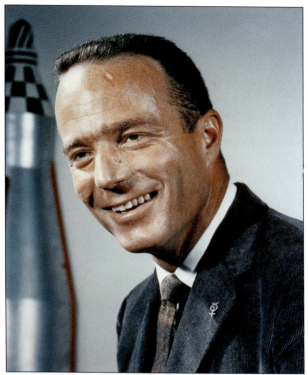

Carpenter passed away in 2013 following a career that took him to the depths of the ocean. He holds the record for spending 30 days in an underwater environment. Here, his wife, Patty, receives the flag from his coffin following funeral services in Boulder, Colorado. Lifelong friend John Glenn (fourth from left) eulogized him and closed with "Godspeed, Scott Carpenter . . . Great friend, you are missed." His cremains are buried on his family ranch in Colorado. (NASA.)

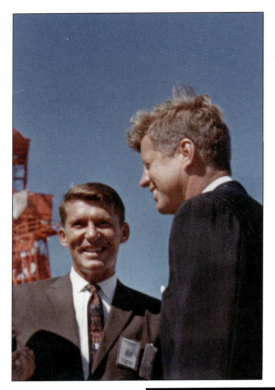

Wally Schirra is seen with JFK in Cape Canaveral in 1963. He spoke of the camaraderie felt between the astronauts and the president. "We were his favorites, part of his little group. All of us felt very comfortable with the President of the United States . . . He was a buddy." Schirra was the only astronaut to fly a Mercury, Gemini, and Apollo mission. (NASA.)

In December 1965, Schirra was the command pilot of *Gemini VI-A*, which rendezvoused with *Gemini VII*—a monumental step toward the moon. Gene Kranz said, "Rendezvous was an absolute necessity if we were to achieve the goal of putting a man on the moon." They came within a foot of each other. This photograph was taken by Schirra of *Gemini VII* from his craft, which is in the foreground. (NASA.)

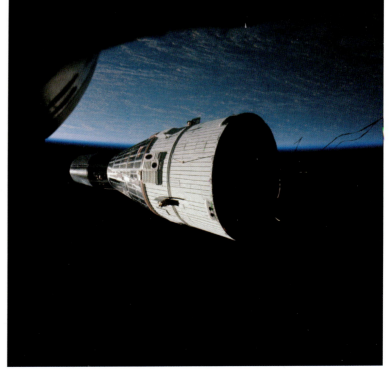

Schirra commanded *Apollo 7*, the first manned flight after the fire of *Apollo 1*. The flight was an overwhelming success technically and put NASA back on track for the moon. However, Schirra and his two other crew members came down with head colds, which left them miserable and cantankerous throughout the flight. Schirra (left) retired following the flight, and his crew of Donn Eisele (center) and Walter Cunningham (right) never flew again. (NASA.)

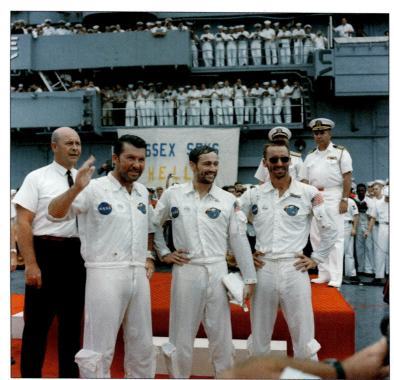

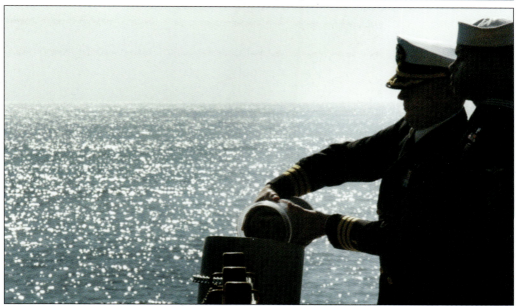

Schirra became a CBS TV commentator for future Apollo flights and was at the desk with Walter Cronkite when Neil Armstrong walked on the moon. He remained there the rest of the Apollo flights. He died in 2007, and here, his ashes are scattered at sea by Comdr. Lee Axtell, chaplain, aboard the USS *Ronald Reagan*. Eight other military veterans joined Schirra at rest in the sea. (US Navy, CS Joseph M. Buliavac.)

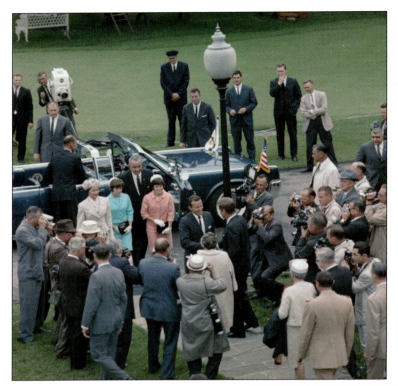

JFK greets Maj. L. Gordon Cooper and his family upon their arrival at the White House in May 1963. Cooper was at JFK's dedication of the Aerospace Center in San Antonio, Texas, on November 21, 1963. Cooper wrote that JFK "asked me if I could go to Dallas with him the next day . . . He said he could use a 'space hero' with him on the trip." Cooper could not attend. (Stoughton.)

Cooper commanded the record-setting flight of *Gemini V*. He, along with Pete Conrad, remained in orbit for eight days and 120 orbits. It marked the first time the United States held a duration record in space. He is hoisted out of the water and then transported to the deck of the USS *Lake Champlain*. (NASA.)

Gordon Cooper's passion for flying extended far beyond his lifetime. Cooper passed away in 2004, and he was cremated. Three separate attempts were made to launch his cremains into orbit. The first two failed, but in May 2012, Cooper finally made his last flight. Launched aboard Celestis's *New Frontier Flight*, he, along with 300 cremains, achieved orbit. With him was actor James Doohan, who played Scotty in the *Star Trek* series and movies. (AC.)

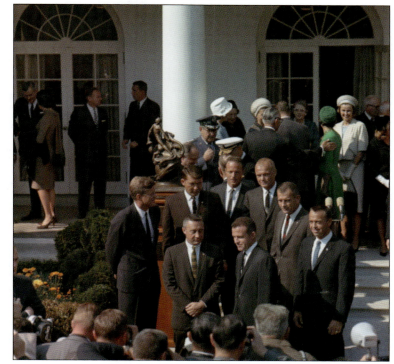

The last time the president and the original seven were together was October 10, 1963, when the president presented them with the Collier Trophy. The Collier Trophy (seen behind the group) is an annual American Aviation Award, which began in 1912. Moving to JFK's left around the circle are Wally Schirra, Scott Carpenter, John Glenn, Deke Slayton, Alan Shepard, Gordon Cooper, and Gus Grissom. (JFK Library, Stoughton.)

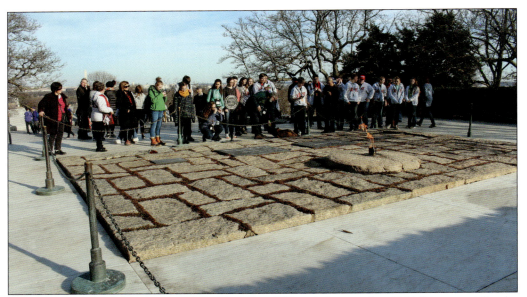

Space exploration wove a special bond between JFK and the people of NASA, especially the astronauts. Alan Shepard recalled the enormous personal interest that he had in all of them. Shepard's wife, Louise, said it best: "His reaction is one of being happy to be associated with you as a group and as individuals because of what you've done . . . recognize a challenge and to be willing to meet the challenge. He was in favor of the program, he was proud of what we [all] had been able to do." Following Kennedy's death, Gene Kranz said, "It moved from a challenge to a crusade . . . our mission was to win this battle for President Kennedy . . . It was visceral, we are going to do it and we're going to do it in the time frame he said we'd do it." Said Slayton, "We felt we owed it to him." (Both, RPS.)

Six

Mission Accomplished
We Made It, Mr. President

Under President Kennedy's leadership, the course to the moon was chartered—from Mercury, the god of travelers, to Gemini, Latin for twin, to Apollo, the Greek god who ruled the sky.

When President Kennedy, a naval man who set America's sights on the moon, presented John Glenn the NASA Distinguished Service Medal in 1962, he said, "In the not too distant future, a Marine or a naval man, or an Air Force man will put the American flag on the moon." Neil Armstrong, a naval man, did just that on July 20, 1969, becoming the first human to set foot on the moon. An Air Force man, Eugene "Buzz" Aldrin helped him plant the American flag. Completing the circle, naval man Eugene Cernan was the last man to walk on the moon in December 1972.

By the end of the 1960s, the United States had successfully completed 25 manned spaceflights and the Soviets, 16. The final flight of the 1960s came in November 1969 when *Apollo 12* successfully landed on the moon. By the end of the decade, the United States landed men on the moon and returned them safely to Earth not once but twice.

President Kennedy spoke often of the dangers and hazards inherently present in any space exploration. A total of 45 Americans have paid the last full measure of devotion in the quest to explore space. Of those 45, a total of 24 were astronauts; 9 of whom perished in training exercisers or test flights, including the *Apollo 1* launchpad fire. Fifteen perished in spaceflight—an X-15 test pilot in 1967 and the crews of two space shuttles. In 1986, *Challenger* exploded 73 seconds into the launch, taking the lives of its seven crew members. In 2003, *Columbia* disintegrated on reentry, and seven more lives were lost.

A half century has passed since Armstrong and Aldrin set foot on the moon, and since 1972, it has been devoid of human activity. However, on August 23, 2018, Vice Pres. Mike Pence toured the Johnson Space Center in Houston and said, "While our sights are once again set on our lunar neighbor, this time we're not content with just leaving behind footprints—or even to leave at all . . . The time has come, we really believe, for the United States of America to take what we have learned over these so many decades, put [NASA's] ingenuity and creativity to work, and establish a permanent presence around and on the moon." The goal the vice president set was the year 2024.

Cape Canaveral has not launched a manned flight since July 2011, but as America moves forward, it again looks toward the moon. How long will it be before Cape Canaveral becomes the focal point of a renewed quest that will take Americans, once again, from Florida to the moon?

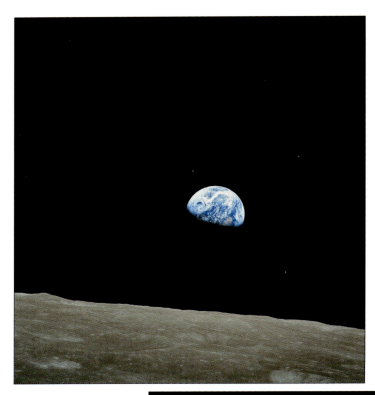

At 7:51 a.m., on December 21, 1968, *Apollo 8* launched from Cape Kennedy, Florida, as Frank Borman, James Lovell, and William Anders became the first humans to orbit the moon. This flight was broadcast in 15 languages throughout 54 countries. On Christmas Eve, in a live broadcast, the crew read from the book of Genesis with Commander Borman finishing with: "And from the crew of *Apollo 8*, we close with good night, good luck, a Merry Christmas and God bless all of you—all of you on the good Earth." One in every four people on Earth was tuned in for that broadcast. (NASA, William Anders.)

In May 1969, *Apollo 10*, the "dress rehearsal" for the moon landing, was launched from Cape Kennedy, commanded by Thomas Stafford. John Young was the command module (Charlie Brown) pilot, and Gene Cernan was the lunar module (Snoopy) pilot. Here, Snoopy approaches Charlie Brown for re-docking after getting within eight miles of the lunar surface. Stafford (Apollo-Soyuz), Young (*Apollo 16*), and Cernan (*Apollo 17*) all flew future Apollo missions. (NASA, John Young.)

On July 16, 1969, *Apollo 11* streaks by the American flag bound for the moon, and five days later, Neil Armstrong and "Buzz" Aldrin placed the American flag on the moon's surface. Some interesting mementos were carried along with Armstrong, Aldrin, and Mike Collins. A piece of wood and fabric from the wing of the *Kitty Hawk*, the first plane flown by Wilbur and Orville Wright. Also, an astronaut pin in memory of Gus Grissom, Ed White, and Roger Chaffee, the lost crew of *Apollo 1*. When Neil Armstrong stepped into the gray powder of the moon's surface, it was 2,978 days, 10 hours, and 26 minutes after JFK stood before a joint session of Congress saying, "I believe that this nation should commit itself to achieving the goal, before this decade is out, of landing a man on the moon and returning him safely to earth." Mission accomplished, Mr. President! (Both, NASA.)

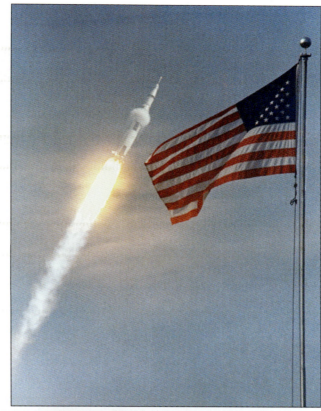

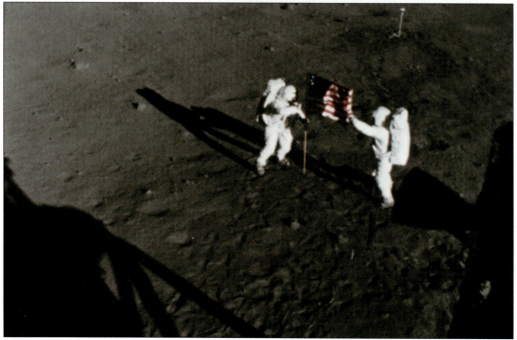

Discover Thousands of Local History Books
Featuring Millions of Vintage Images

Arcadia Publishing, the leading local history publisher in the United States, is committed to making history accessible and meaningful through publishing books that celebrate and preserve the heritage of America's people and places.

Find more books like this at
www.arcadiapublishing.com

Search for your hometown history, your old stomping grounds, and even your favorite sports team.

Consistent with our mission to preserve history on a local level, this book was printed in South Carolina on American-made paper and manufactured entirely in the United States. Products carrying the accredited Forest Stewardship Council (FSC) label are printed on 100 percent FSC-certified paper.